THE FUNDAMENTALS OF
OIL PAINTING

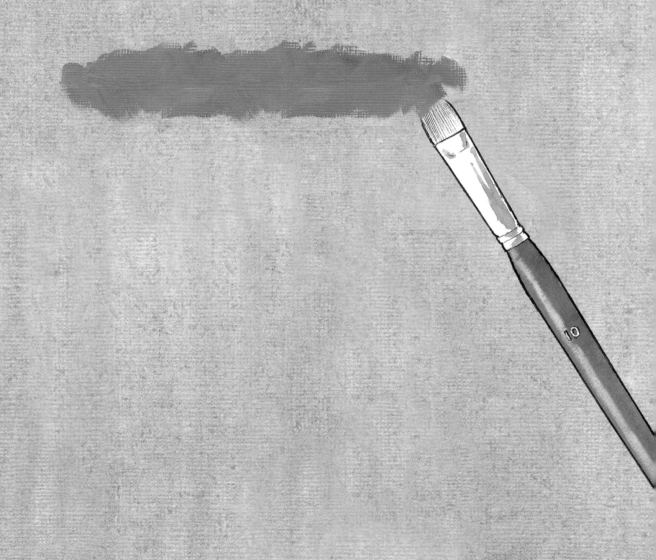

THE FUNDAMENTALS OF
OIL PAINTING

A COMPLETE COURSE IN TECHNIQUES, SUBJECTS AND STYLES

Barrington Barber

ARCTURUS

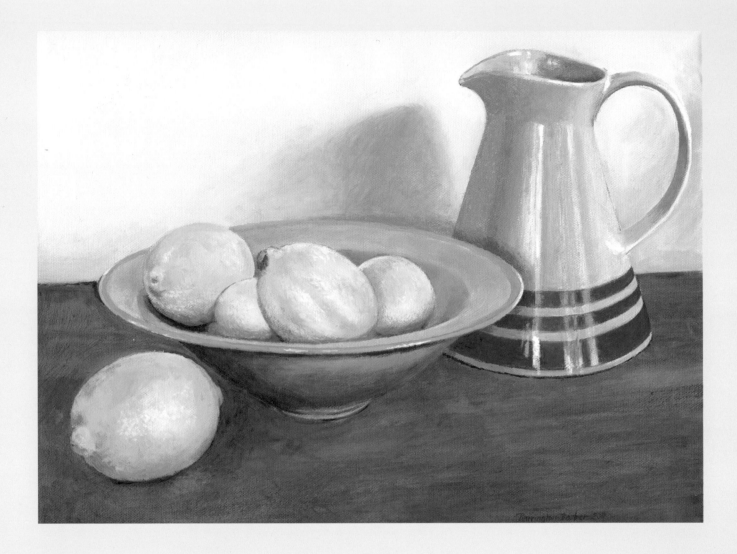

Arcturus

This edition published in 2012 by Arcturus Publishing Limited
26/27 Bickels Yard, 151–153 Bermondsey Street,
London SE1 3HA

ISBN: 978-1-84858-468-6
AD001894EN

Printed in Singapore

CONTENTS

INTRODUCTION

The object of this book is to help would-be artists to make a start on the enjoyable activity of oil painting. While this is probably the method of painting most used by professional artists today, it shouldn't appear too daunting to those who would like to try it out; of all the painting mediums, oil paints are the most flexible to use and they are capable of both strong effects and subtle qualities. What is shown in this book is a way into handling the techniques for using them, which I have aimed to make as simple as possible. Of course as you progress you will find that there are many approaches you can try until you find the way that suits you best.

The book starts with an exploration of the materials that you will need, and again I have tried to keep it relatively simple. There are many types of paints and tools at your disposal, and when you go into an art shop you will find a bewildering amount of things to use. Although all of these may come to your notice at some time, I have restricted the ones included here to those which I have found most useful and universal. As you become more skilful you may want to branch out into a larger variety of equipment, and that will be the right time to experiment.

The methods artists use also vary enormously, but the main thing is to get started in the easiest way possible and that will then lead on to more extensive practices; after learning the basics, you should experiment as much as you can. Even if your first steps appear to be ineffective, by continuing to try them out you will improve. With practice, you really will become a better artist.

We shall also be thinking about the options that you have when faced with a blank canvas. What will you paint? How will you compose your picture? What style and method will you use? All these decisions are crucial to making a successful oil painting, and we shall look carefully at each step of the process, taking the fields of still life, landscape, portraits and figures one by one before finishing with an overall look at the styles and compositions used by notable artists of the past and present.

Barrington Barber

CHAPTER 1

MATERIALS AND COLOURS

In this section we'll look at everything you will require to make a start in oil painting, including brushes, supports, easels and of course colours and an understanding of their relationships with each other.

The multifarious things that may be found in an artist's studio are so extensive in range that you could spend enormous amounts of money acquiring them all, only to discover that you use just a few of them. Here I have described items that you will need at once, and only when you know a bit more about what you are doing should you extend your range of materials.

You can paint with very little, so long as you have pigments, brushes and a surface on which to paint. Even an easel is not entirely necessary, although if you take up oil painting seriously you will probably want one. The most important things are worth spending some money on, because the better materials last longer and feel better to use than the very cheapest. However, if you do buy the cheapest you will find you can still paint quite well – although you may have to replace them more often, making them not as economical as they seemed at first.

A little knowledge of colour values and how they work in painting is not difficult to master, and your handling of colour will become more subtle as you progress. Eventually mixing colours becomes almost automatic and you will surprise yourself with how effective your use of them has become.

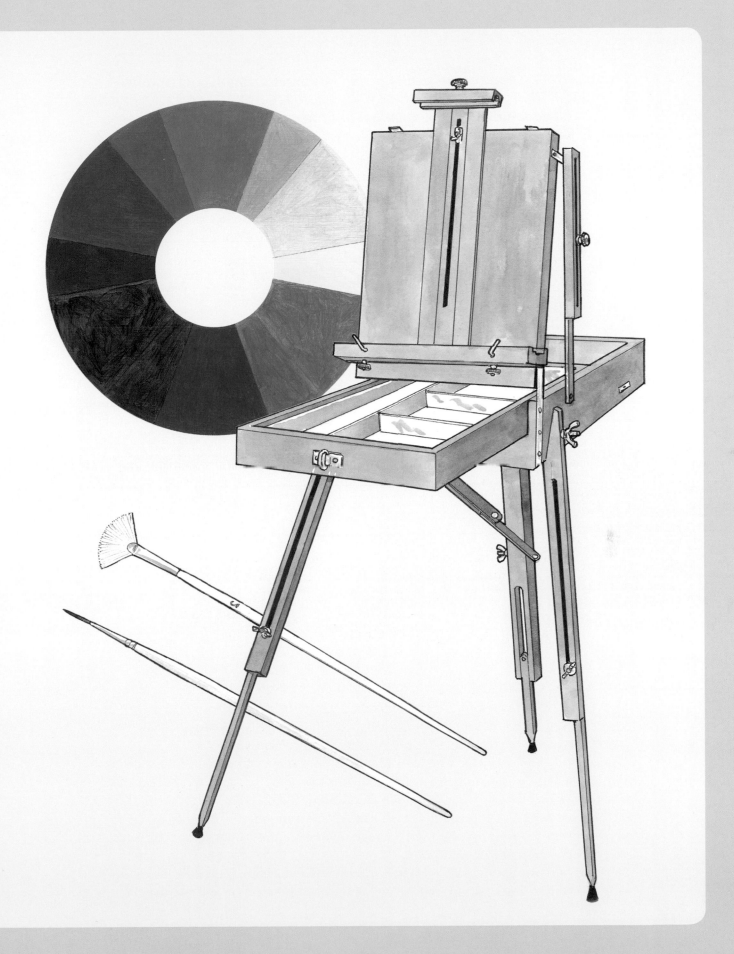

BRUSHES

While oil paintings can be done entirely with bristle brushes, it's useful to have softer brushes too for detail or for subtle areas where you want to reduce brushmarks. You'll need quite a few brushes if you really get into painting, but you can build them up over time.

Buying cheaper brushes can be a false economy as the better types tend to last much longer, so it's best to get good-quality ones from the outset if possible and look after them carefully (see box). Here is my basic list of brushes, which will be more than enough to get you started.

Bristle Brushes

These are usually made from hog's hair, though synthetic ones, which are normally softer, are also available. They come in a range of styles, each with its own purpose.

Flats

Flat brushes have a flattened set of bristles, rather like a refined version of a decorator's brush. They are the brushes you'll use most of the time, as they hold the paint well and you can apply it to your support with both the wide surface and the edge to get varying brush marks. The following sizes are a useful range: 20 (probably the largest you will need unless you wish to paint murals), 12, 10, 8, 4, 2 and 1.

Cleaning Brushes

To clean brushes, first wipe off excess paint with a kitchen towel or rag, squeezing them from the ferrule downwards but taking care not to pull on the bristles. Rinse them in white spirit first to get the paint out of the hairs – you can push hog's hair brushes about in the spirit, but you need to be much gentler with sables or they will lose their point. Wash them in soap and cold water to clean out the white spirit and any remaining paint then, once you're sure they are clean, give them a final rinse in water. Reshape the brushes gently with your fingers and leave to dry. Never stand them up resting on their bristles as this will destroy the shape.

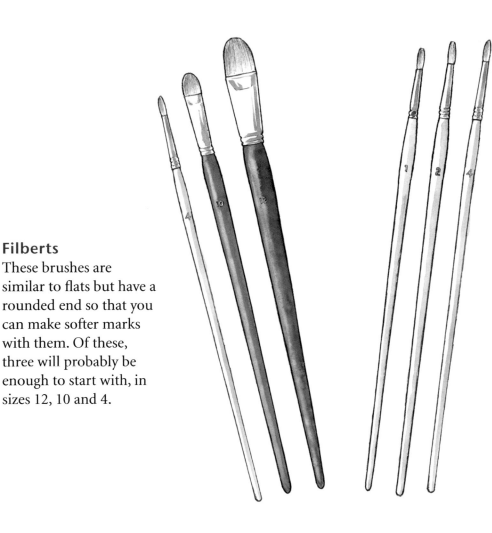

Filberts

These brushes are similar to flats but have a rounded end so that you can make softer marks with them. Of these, three will probably be enough to start with, in sizes 12, 10 and 4.

Rounds

As you might expect from the name, these brushes are rounded down the whole length of the bristles. They can be very useful because they are capable of holding more paint, allowing you to pile it on more easily. They are also good for scumbling, as the bristles spread out in all directions. You will need sizes 4, 2 and 1.

Soft Brushes

The best soft brushes are made from sable hair, but if your budget is tight the cheaper brushes made from squirrel, ox or synthetic hair are very acceptable. I recommend you have one large brush, size 12, and three in sizes 4, 1, and 0; these smaller brushes are ideal for the very fine marks that you might wish to make before you finish your painting.

Soft brushes for oil painting have longer handles than those for watercolour, partly so that you can keep your hands away from the wet paint but also to enable you to stand back from your painting.

Other Brushes

Once you get going you may find that some brushmarks are too difficult to make without more specialized brushes, so the following three types are worth considering.

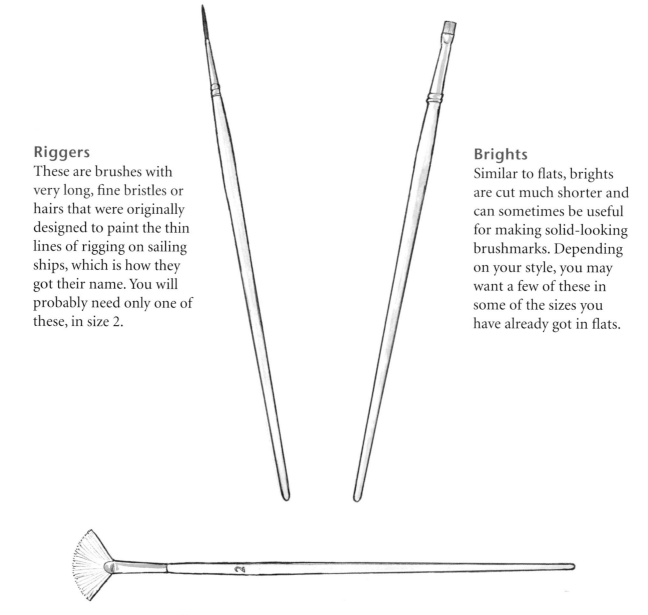

Riggers

These are brushes with very long, fine bristles or hairs that were originally designed to paint the thin lines of rigging on sailing ships, which is how they got their name. You will probably need only one of these, in size 2.

Brights

Similar to flats, brights are cut much shorter and can sometimes be useful for making solid-looking brushmarks. Depending on your style, you may want a few of these in some of the sizes you have already got in flats.

Fans

Fan-shaped brushes are ideal for softening the edges of your painted marks. Just one, in size 2, should suffice.

PALETTE KNIVES

There are quite a few variations of size and shape in the range of palette knives available, but unless you're going to start doing a lot of knife painting two will be enough. Of the ones shown here, the larger-bladed one (right) is very useful for cleaning palettes and mixing large amounts of paint. The smaller blade (below) is good for using to mix paint instead of using your brush and is also the best type for painting on the canvas if you need thicker marks. With these two you can do most of the techniques that will be shown in this book.

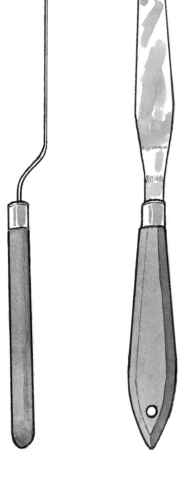

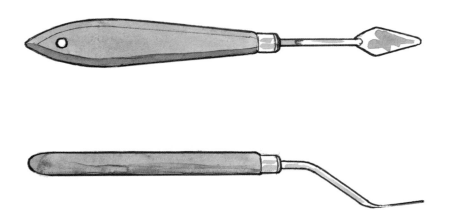

MAHLSTICK

A mahlstick is a device that painters have used for many centuries to steady their hand when painting details in a picture. Some art shops sell them, but it is easy enough to make your own: just pad out a piece of cloth or soft leather into a ball as shown and tie it tightly on to the end of a straight stick. This gives you a support on which to rest your painting wrist (see page 35).

PALETTES

You can buy many kinds of palette, but essentially they are all just a flat surface that you can keep all your colours on. The traditional palette is shaped in an ellipse with a thumbhole and a deep curve cut into the side, which enables the painter to hold the palette with one hand and the brush or palette knife with the other. Nowadays palettes come in many shapes, often rectangular or round and usually with a thumbhole.

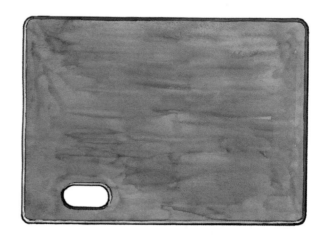

I often have my palette lying flat on a surface next to me, so the particular shape doesn't matter – all that's needed is a surface that will not soak up the paint, and most heavily varnished boards can be used this way. Some artists use glass or plastic surfaces to mix paint on, so you can experiment and see which you prefer.

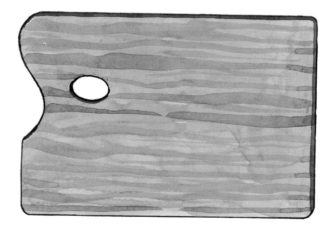

Disposable palettes come in pads of several sizes and can be useful, if eventually rather expensive; you simply tear off a sheet of paper and tape it to your table. Tracing paper or waterproof paper will work equally well. In my view a hard palette feels nicer and lasts for as long as you want, but if your clearing-up time is limited or you are trying to cut down on weight when working on location you may find a disposable palette practical to use.

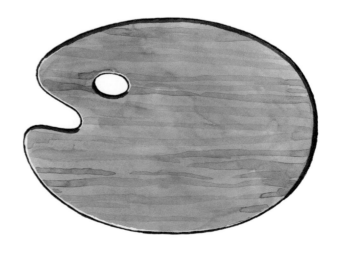

PAINTS

Some artists mix their own paints from raw pigment, but the quality of the paint in tubes, ready to use, is good enough for most people. The most common sizes of tube are 37ml and 200ml and you should find the former adequate for most colours, though it's worth buying white in the latter size as you will probably get through larger quantities of that. As long as you use up all the paint, the larger sizes work out to be much more economical – something to bear in mind if you develop a painting style that uses a lot of paint in particular colours.

I always use oil paints ready-mixed with alkyd medium, which speeds up the rate of drying. You will be able to find them in most art shops and online stores. I often want to paint over dried paint, and as alkyd oil paint dries in about 6–12 hours I can do that after leaving it overnight. If this is not something you need then traditional oil paint will do, but it does take a good while longer to dry; exactly how long will depend on the colour, how thickly you have applied it and which medium you have used.

The colour names given in this book are for the pigments I use, but you should be able to find near equivalents in all manufacturers' ranges. Conveniently, colour charts can be found on the Internet by searching for the manufacturers' websites.

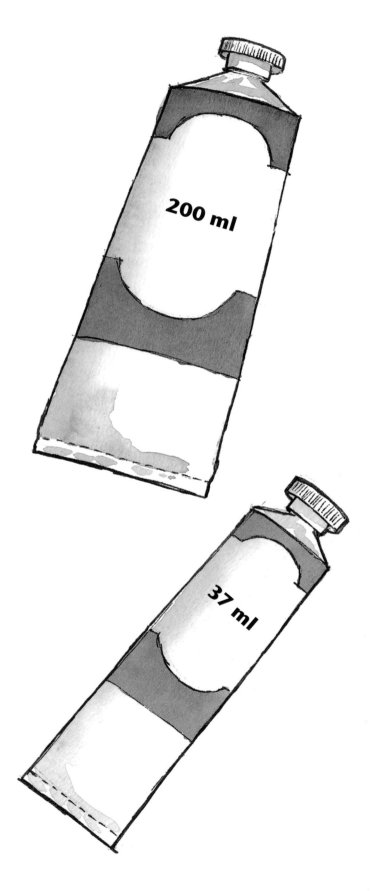

DILUTANTS

The most commonly used dilutant or thinner for oil paint is turpentine. This is not the ordinary household turps, which will affect the colours of the paint, but refined distilled turpentine, which is usually sold only in art shops. It does have a strong smell, which I love, but if you don't like it you can get low-odour substitutes such as Zest-It, Sansodor or Shellsol. Some people are allergic to turpentine, so if you are painting in a group or using a model it is always best to use a substitute.

2 litre

1 litre

MEDIUMS

The most popular medium is linseed oil (pictured left); for the best effects you should use the refined, cold-pressed version. It will add considerable oiliness to your paint, and I don't use it myself because the paint in the tube has enough oil in it already as far as I'm concerned. All mediums are a matter of personal choice and you will find a range of them offering different qualities in most art supplies shops, a much-used one being Liquin, which gives a very smooth layer of paint and is good for glazes (see page 49). It also has dryers in it that help the paint to dry quickly.

VARNISH

The main purpose of a varnish is to protect the painting, but it also harmonizes the surface quality of the paint so that you don't see matt and shiny surfaces next to each other. Varnishes come in both gloss and matt surfaces, and which you choose depends on the final effect you wish to achieve. There is also a type called retouching varnish, which you can use as normal but is particularly good if you wish to work on a painting again some time later. It allows the new paint to bind with the dried paint more effectively and helps to prevent cracking (see page 35).

You can't apply a varnish until the painting is really dry, which will be several days or even weeks after you have completed it. I find that with the quick-drying paint a week or so is sufficient drying time, but with traditional oil paint you will need to wait much longer. White seems to be the slowest-drying pigment of all, especially when it is very thick.

CANVAS AND BOARD

The most traditional surfaces to paint on in oil are canvas and boards of different kinds. The great advantage of canvas is that it is very light to handle and can be easily transported and stored. It is stretched tightly across a wooden frame and then pinned to it with either staples or small nails. In the inside corners at the back of the canvas are slots that wooden wedges can be tapped into with a small hammer to stretch the canvas even tighter (see below). You do need your canvas surface to be as taut as possible in order to paint easily on it.

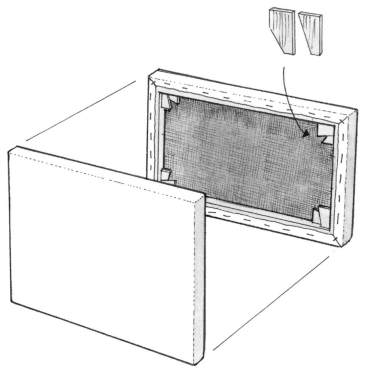

When you buy ready-stretched canvases in art shops, they are already sized and coated with a white primer that gives you a good surface for painting. Many painters like to stretch and prepare their own canvases, but I suggest that until you have really got into oil painting buying stretched canvases is a sensible practice as you can quickly get going. These days you can get many cheap and well-made canvases, from which you can progress to stretching more expensive fabrics yourself when you feel ready to.

Canvas boards, which are simply canvas glued to a stiff board, are also a very useful surface for painting, and they don't take up quite so much room as canvases on wooden stretchers.

It's also possible to paint on a type of canvas paper that you can buy in art shops and this is often a good way to start oil painting because it is easily put away, having no more bulk than a thick sheet of paper. You can also get rid of it more easily if you don't like your first attempts at painting! This paper usually comes in large and small pads, like a sketchbook, but is also sold in single sheets.

A very economical way of providing yourself with a painting surface is to buy pieces of MDF or good plywood board from a timber yard or DIY store. They come in a variety of thicknesses and any are suitable for your purposes, though of course the added weight of the thicker board makes it less practical. You may find the staff are prepared to cut board to the exact sizes you want, but if not you will have to buy a length and saw it up yourself.

You will need to prepare the surface – back, front and edges – with acrylic gesso, which is a thick white painting medium that coats board very well; several coats may be required to achieve a surface that is good to paint on and to protect the board from damp, which would cause warping. Sanding down with fine sandpaper helps to smooth the surface.

The only drawback to these painting surfaces is that the final work is much heavier than canvas and therefore not so easy to transport. Wooden boards were the traditional way of painting until the Renaissance period, when canvas became more popular, because of the ease of transportation and storing. As you can imagine, a large painting on solid wood would have been very heavy and difficult to move around.

EASELS

You don't need an easel in order to start painting, but it does make life easier; you can keep your studio space much cleaner, and the painting can be left on the easel to dry in safety. I like radial easels (see facing page), which are sturdy enough to support most canvases and give a very firm base to work on, with the advantage that they are easily folded up to put away or carry to a new venue.

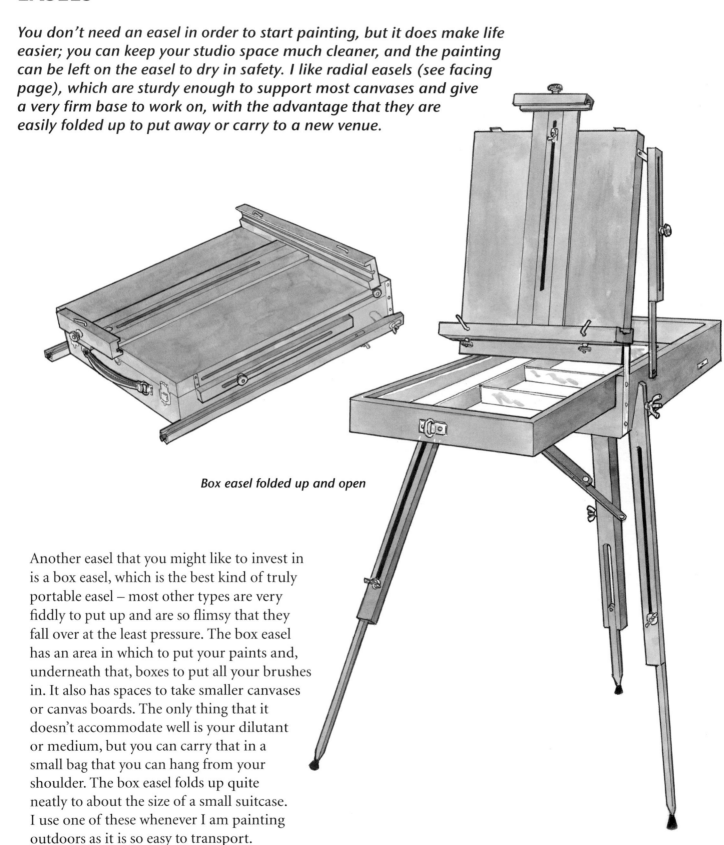

Box easel folded up and open

Another easel that you might like to invest in is a box easel, which is the best kind of truly portable easel – most other types are very fiddly to put up and are so flimsy that they fall over at the least pressure. The box easel has an area in which to put your paints and, underneath that, boxes to put all your brushes in. It also has spaces to take smaller canvases or canvas boards. The only thing that it doesn't accommodate well is your dilutant or medium, but you can carry that in a small bag that you can hang from your shoulder. The box easel folds up quite neatly to about the size of a small suitcase. I use one of these whenever I am painting outdoors as it is so easy to transport.

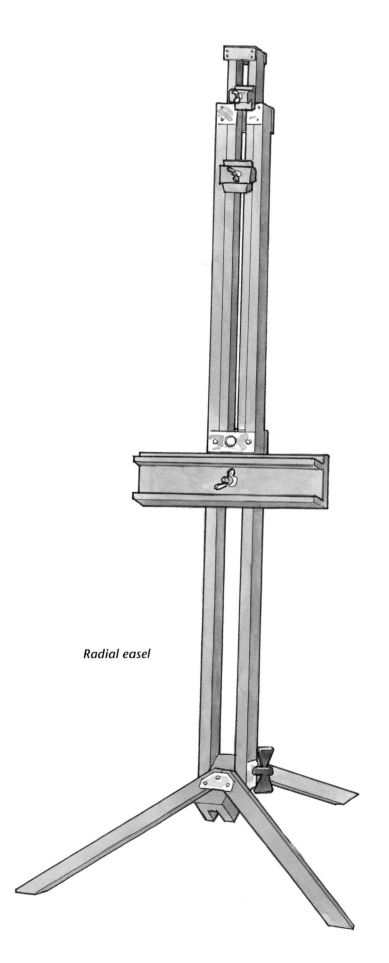

Radial easel

LIGHTING

Good lighting is essential for an artist, and the ideal is a studio with a north-facing window high in the wall or in the ceiling to give an even light, with plenty of directional artificial lighting available as well. Most of us don't have the ideal situation, of course, but that needn't stop us painting.

In my studio I have good artificial lighting so that I can work late at night if necessary. Apart from overhead lights, I have a couple of small spotlights so that I can adjust the angle of light to my needs. If you don't have them installed in the room circuit, a small directional lamp will suffice.

COLOUR THEORY

In order to use colours effectively in your paintings you need to understand at least the basics of colour theory. Colour is never seen in isolation, so how we perceive it is always in relation to another colour or to white or black. For the purposes of artists, colours are generally shown arranged in the form of a wheel to make it easier to see their relationships.

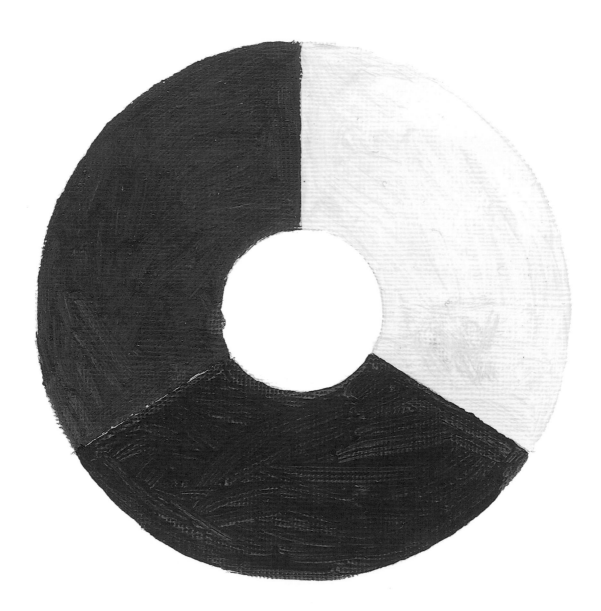

Primary colours
This wheel shows the three primary colours: red, blue and yellow. All other colours are made by mixing the primary colours, which cannot themselves be achieved by mixing.

Secondary colours

The colours made by mixing two primary colours together are called the secondary colours, and in this colour wheel they are shown between the primaries from which they are derived. So, blue mixed with red makes purple; red mixed with yellow makes orange; and yellow mixed with blue makes green.

The colours immediately opposite each other across the circle are called complementary colours – so red and green are complementary, blue and orange are complementary, and yellow and purple are complementary.

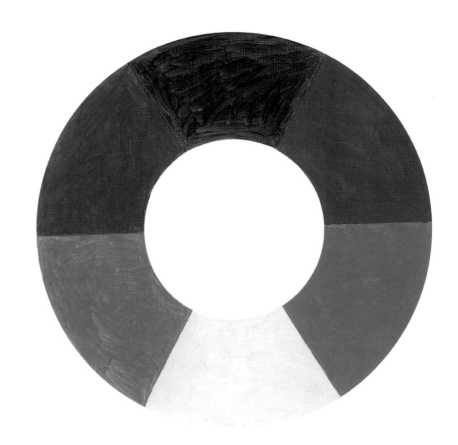

Tertiary colours

The tertiary colours are mixtures of the primary colours with the secondary colours. This extended colour wheel shows the secondary colours in between the primaries, and tertiary colours either side of the secondaries.

By mixing primary and secondary colours, you can make all the variations in colours you need, sometimes with the addition of white to reduce their darkness. This is how you will find all your neutral colours – greys and browns (see page 30).

23

BASIC COLOUR RANGES

The first colours that you will need are of course the three primary colours. I suggest Cadmium Yellow Light (or Pale) as the yellow, Cadmium Red Light as the red and French Ultramarine as the blue. As you can see, these are very clear colours and are a good base from which to start.

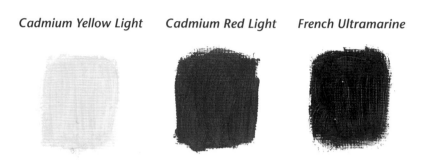

Cadmium Yellow Light Cadmium Red Light French Ultramarine

However, to mix all the subtle variations possible in your palette you will need to buy variations on these primaries. I recommend Cadmium Lemon and Naples Yellow to open out the yellow range, Alizarin Crimson and Vermilion to open out the red range, and Cerulean Blue and Dioxazine Purple (which is really a violet) to open out the blue range.

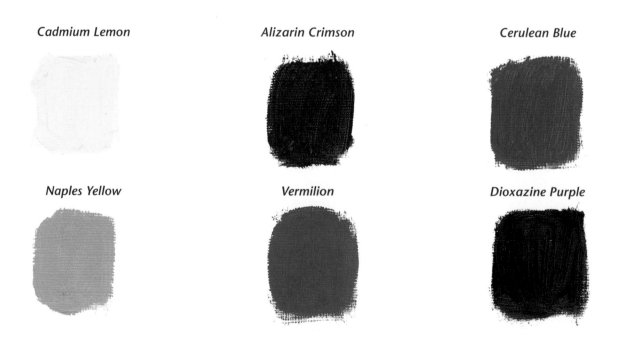

Cadmium Lemon Alizarin Crimson Cerulean Blue

Naples Yellow Vermilion Dioxazine Purple

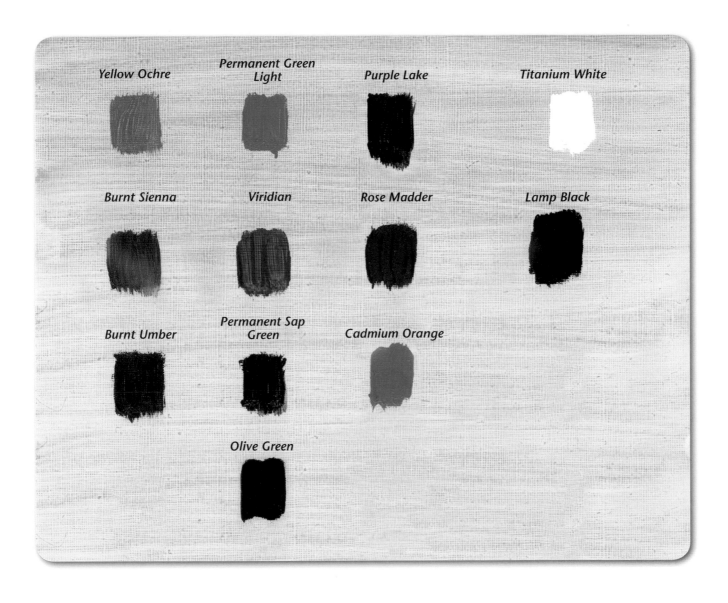

Even with this range of colour you will still need to mix most colours that you
wish to paint with, so a few more will be helpful: for browns, Yellow Ochre,
Burnt Sienna and Burnt Umber; for greens, Permanent Green Light, Viridian,
Permanent Sap Green and Olive Green; Purple Lake, mainly for mixing with
other colours to get interesting tones; Rose Madder as a softer version of Alizarin
Crimson; and Cadmium Orange to beef up warm colours when you need it.
Of course no range of colours would be complete without white and black, so
I suggest Titanium White and Lamp Black as two good versions of these. While
there is a huge range of tempting colours available, I find these are all I need.

COLOUR TEMPERATURE

When we look at colours, the brain interprets what we see as being either warm or cool. Traditionally, the warm colours are reds, oranges and yellows (the colour of fire and the sun), plus the warmer browns; the cold colours are blues and blue-greys and some blueish-greens. However, to make things a bit more complicated, some cool colours tend towards warm and some warm ones tend towards cold. Yellow is generally seen as warm, for example, but with the addition of some green to create a more acidic lemony colour it can be seen as cooler; if, however, you made it a little more orange it would become warmer since it would be closer to red.

Below is a list of colours giving examples of warm, intermediate and cold values.

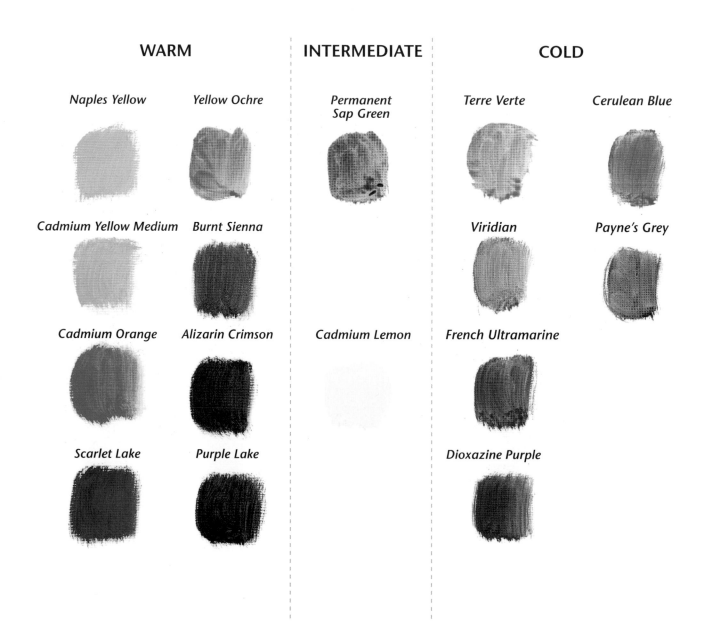

WARM		INTERMEDIATE	COLD	
Naples Yellow	Yellow Ochre	Permanent Sap Green	Terre Verte	Cerulean Blue
Cadmium Yellow Medium	Burnt Sienna		Viridian	Payne's Grey
Cadmium Orange	Alizarin Crimson	Cadmium Lemon	French Ultramarine	
Scarlet Lake	Purple Lake		Dioxazine Purple	

Shadow and Light

When you're painting scenes with strong light cast over them you'll find that where the light is warm the shadows will appear cooler and, conversely, with a cool light the shadows will be warmer. Conveying this will help enormously to give greater depth and vibrancy to the picture.

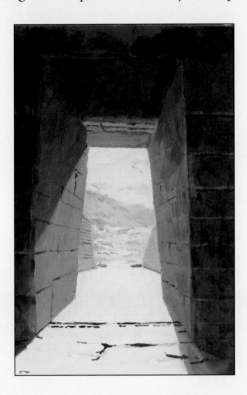

Warm Light, Cool Shadows

In this painting of the entrance to Menelaus's tomb at Therapne, the outside landscape is bathed in hot sunlight. Everything outside the tomb is in hot yellow tones, to give an effect of Mediterranean sunlight. Within the darkness of the tomb the shadows are very blue and green, with a touch of violet. These colder colours contrast with the outside colours, emphasizing their warmth.

Cold Light, Warm Shadows

Here a runner is just finishing a race, and the predominant light is of cool, pale blues and white with a hint of green. The shadows on the runner's neck and tunic are in warm brownish-yellows and purple. Again the effect gives a strong feeling of the open air, with cool light in contrast to the warm, dark tones on the figure.

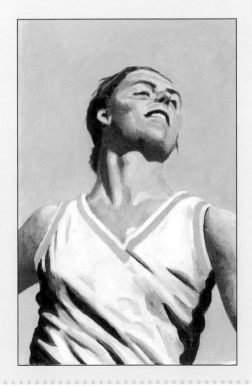

Other Colour Terminology

You may also come across other terms that describe colours, such as those below. If you find them rather confusing, don't be concerned – you will gradually get to know them in conversation with other artists, and your skill doesn't depend on your knowing all the right names.

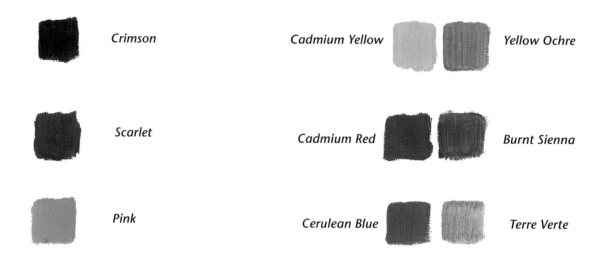

Crimson

Cadmium Yellow · Yellow Ochre

Scarlet

Cadmium Red · Burnt Sienna

Pink

Cerulean Blue · Terre Verte

Hue

This simply describes colours by name, such as red, yellow or blue. Crimson, scarlet and pink all have a red hue, for example.

Intensity

Some colours have greater intensity than others, in that they leap out of the scene much more readily. For example, Cadmium Yellow has a strong intensity, whereas Yellow Ochre is more subdued; Cadmium Red and Cerulean Blue both have strong intensity, whereas Burnt Sienna and Terre Verte have less.

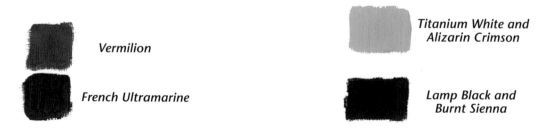

Vermilion

French Ultramarine

Titanium White and Alizarin Crimson

Lamp Black and Burnt Sienna

Tone

When you paint unmixed colours on to a surface some look lighter or darker than others. For example, French Ultramarine is quite dark in tone, whereas Vermilion is much lighter.

Tints and shades

Tints are made mostly by mixing white with a colour to produce a lighter colour. Shades are the opposite, where black mixed with a colour will give a darker version of it.

SETTING OUT YOUR PALETTE

When you lay out your palette for the day, always start with the colours that you know you will need – others can be added as you go along. It's a good idea to put the same colours in the same place on the palette each time as this makes it easier to find them without thinking too much about it.

Let's take the example of painting a figure from life. Before starting a life painting I prepare a canvas with a thin layer of Burnt Sienna, because I don't like to paint on to a white canvas (see page 38). When this is dry I can begin to lay out my palette to start painting. This palette is specifically focused on painting figures from life, but it could also be good for portraiture.

On the left-hand side, I place a range of colours that I find useful for basic colour and tone. Starting at the bottom left and working upwards and around the outer edge of the palette, I place Naples Yellow, then Yellow Ochre, then Burnt Sienna, then Burnt Umber. This gives me most of my basic warm colours.

Then, leaving a small gap, I put a little Flesh Tint, which is a warm light pink, and then some Permanent Alizarin Crimson. These give me all the really warm colours necessary. I don't need much of these two colours.

Now, over on the right-hand side of the palette, nearest to the Alizarin Crimson, I put some Purple Lake or Dioxazine Purple. Next to that I put some French Ultramarine, which is a marvellous blue to give all the colder tints that I might want. It's very strong and I don't use much of it on the figure itself, but it can be useful to build up a tonal background.

At the bottom right-hand edge, I put a little Viridian – a very cool green that can be useful for cool tones on flesh.

Along the bottom edge of the palette, I usually place a large sweep of Titanium White for mixing and lightening all the other colours.

29

MIXING COMPLEMENTARY COLOURS

In order to get subtle greys and browns to balance out your colour range, keeping a harmonic quality to the mixtures, it is best to use complementary mixes of colours rather than buying ready-mixed tubes. This means that you mix the colours that appear on opposite sides of the colour wheel (see page 23). Here you can see what happens when you mix these colours, which complement each other to make up the complete colour wheel.

The first ones to try are French Ultramarine and Cadmium Orange. By mixing these together you get the type of dark grey shown. However, this will probably be too dark in tone for most things, and so you mix some white with it to get the next grey tone. With even more white the grey gets softer and lighter, and you can see this has quite a nice feel to it.

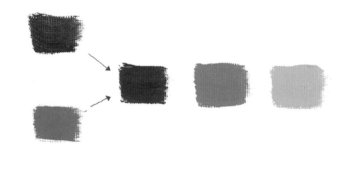

Now try out Permanent Green Light and Cadmium Red Light mixed together. The result is a warm dark brown. Add some white and the tone gets lighter; add more white and you get a lovely yellowish colour.

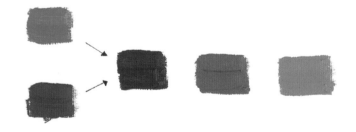

Next try out Dioxazine Purple and Cadmium Yellow Light mixed together and again you get a strong brownish colour. Add some white and you get a more greyish tone; add more white and the tone becomes even more subtle.

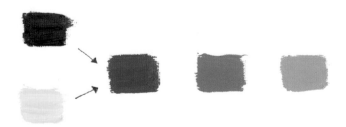

Mix of Cadmium Orange, French Ultramarine and Titanium White

More Orange *More Blue*

Mix of Permanent Green Light, Cadmium Red Light and Titanium White

More Green *More Red*

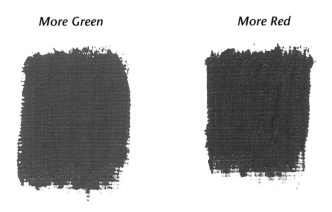

Mix of Dioxazine Purple, Cadmium Yellow Light and Titanium White

More Purple *More Yellow*

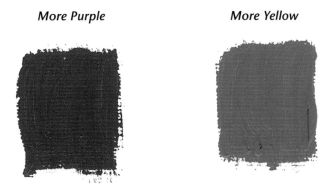

These colours can, of course, be changed slightly by adding more of each of the colours in the above mixes, as shown here. It is worth trying out all these mixes on a large piece of canvas board or oil-painting paper so that you can see all the variations together. This is how you begin to understand how many subtle variations you have available, even with a very restricted palette.

CHAPTER 2

METHODS OF WORK

Once you have the equipment you need, the next thing to explore is how you apply the paint to your working surface and manipulate it successfully. There are many ways to do this, but here we shall stick to the most commonly used methods, which are the simplest and most effective.

Before you start your painting, it's wise to lay what is known as a 'ground' – an overall colour, usually in a mid tone, so that you are not trying to work out the balance of tones against the white of the canvas. We shall look at the thinking behind the colours you might want to choose in relation to the intended picture, before going on to consider drawing your subject in charcoal or with a brush and then the choice of painting techniques that lend themselves to oils. You will discover how to mix, darken and lighten colours, lay thin glazes and heavy impasto and work with palette knives, among other time-honoured methods.

Because oil paintings done in the studio may be very large, we shall also discuss how to use the principle of 'squaring up' to transfer a small work done on location to a much larger scale, allowing you to try out all the skills you are developing.

USING YOUR EQUIPMENT

Once you have assembled the equipment discussed in the previous chapter you will be keen to paint. However, it's worth taking a little time first to make sure you are going about things the right way in order to avoid wasting both time and money.

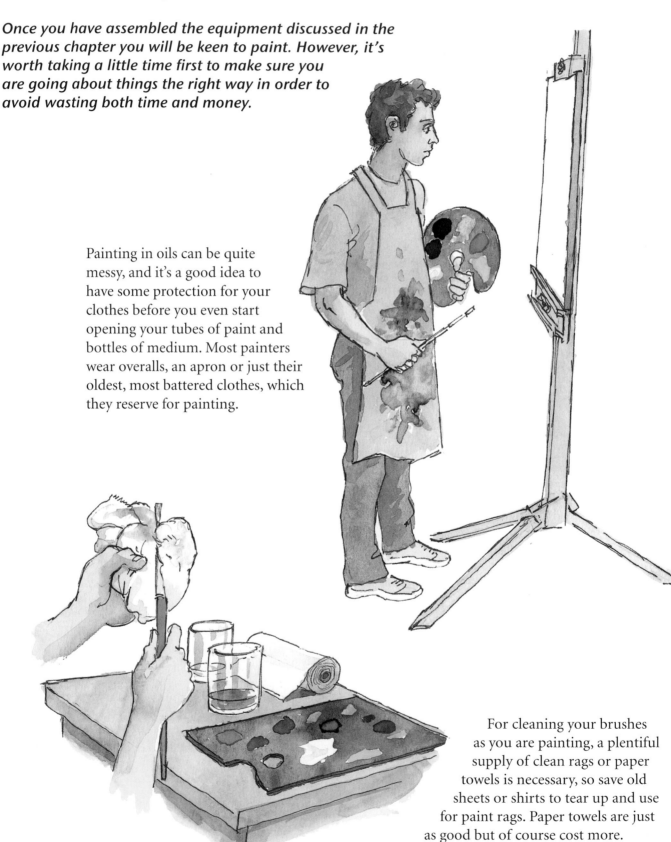

Painting in oils can be quite messy, and it's a good idea to have some protection for your clothes before you even start opening your tubes of paint and bottles of medium. Most painters wear overalls, an apron or just their oldest, most battered clothes, which they reserve for painting.

For cleaning your brushes as you are painting, a plentiful supply of clean rags or paper towels is necessary, so save old sheets or shirts to tear up and use for paint rags. Paper towels are just as good but of course cost more.

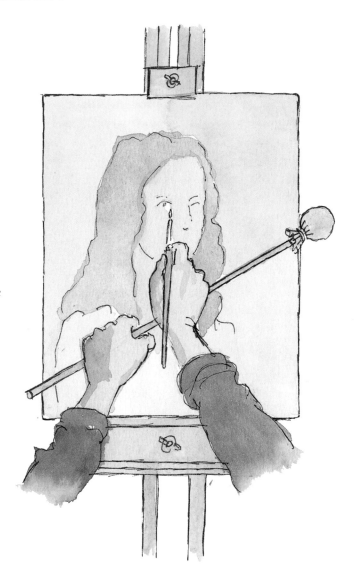

The Mahlstick

This is an aid for painting careful detail, when it's particularly important that your hand doesn't slip or wobble. Place the mahlstick across the painting, held in your left hand if you are right-handed or vice versa, with the ball end resting on the side of the canvas or the easel itself. Then, with your hand resting on the stick part, you can paint very small details with a steady hand.

Retouching Varnish

This varnish allows you to go back to a painting that is dry and add further paint without the likelihood of it flaking off after a few years. Prop up the canvas at an angle of about 45 degrees and then spread the varnish across the painting with a soft, wide brush, starting at the top and working horizontally across the canvas until you reach the bottom. Leave for about an hour for the varnish to dry off and you can then apply the paint, which will bind with the paint already present. The varnish is very fluid – don't use too much or you will end up with a flood of it.

It's best to have a separate brush for varnishing, though it's not essential. Clean the brush in the same way as your paintbrushes (see page 10). Because varnish is clear it is harder to see if the brush is clean, so be especially thorough.

Masking Tape

When you want to paint a hard straight edge, such as in an abstract painting, you can use masking tape to obtain it more easily.

First, lay down the tape to isolate the area of new colour that you want to paint. Apply more pressure to the edge of the tape closest to the colour because it's possible for the paint to creep under the masking tape, especially if it's very liquid.

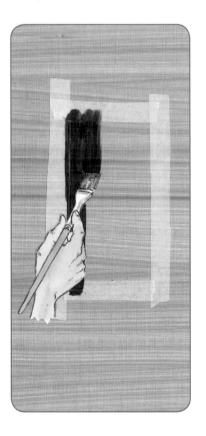

Then, with a broad brush, apply the paint until the whole area is covered.

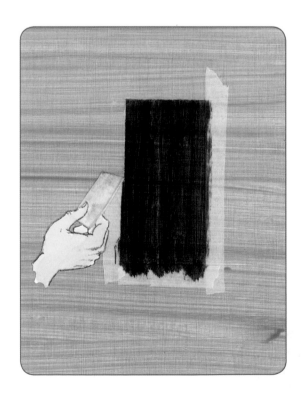

When the paint is dry enough (touch dry is sufficient), carefully peel off the masking tape and you will be left with your straight-edged area of colour. If any tiny flecks of paint have crept under the tape, just touch up afterwards, making sure that the colour mix is exactly the same.

The Easel

An easel serves the purpose of holding the canvas upright and firmly in place so that the artist can apply the paint without accidentally touching it with his or her hands or sleeves, as would be likely to happen when working on a flat surface. It also makes it possible for the artist to see the painting and the scene or model at the same time from the same angle.

In the three examples given here, two show a box easel and one a radial easel. In the studio the latter can be set up with the model or objects placed as the artist wants, so that he or she can see them without moving his or her gaze much from the painting. As you can see in the illustration, the artist has a table nearby on which to put the paints, brushes and mediums.

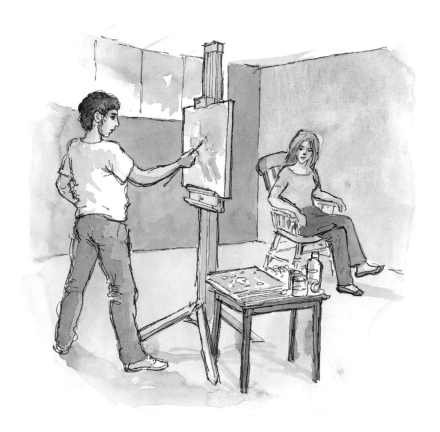

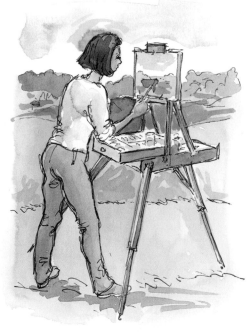

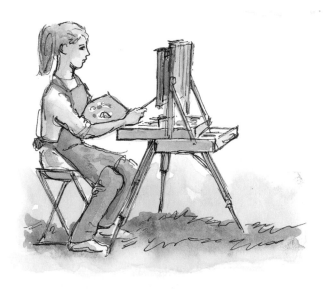

In the second example the artist has a box easel erected outdoors in order to paint a landscape. Sections of the easel hold the paints, brushes and mediums, and even the palette if required, although in this picture the artist is holding the palette in her left hand.

In the second outdoor scene the artist is sitting at the easel, with the legs shortened to accommodate the height of her viewpoint. I prefer to paint standing up, but many artists like to be seated. Whichever you choose, remember to stand back periodically to view your painting from a greater distance.

TECHNIQUES

By this stage you are ready to start – with all your equipment to hand and some knowledge of how to use it – and now you have the challenge of actually applying paint to a blank surface. You may already have some experience with other mediums, but even so, many artists find a first encounter with oils and canvas, the materials used by the Old Masters, somehow more daunting. In fact, because you can scrape or wipe oils off, or simply paint over your mistakes, you will find them a very forgiving medium.

Laying A Ground

Most artists don't like to paint directly on to a white canvas because the intensity of the contrast between the canvas and the colours as they are applied make it difficult to work out the balance of tones. To avoid this, they usually cover their canvas with a neutral mid-tone colour, such as a brown or greenish-grey. This is known as a base colour or 'ground'.

Here is a canvas board covered with a thin layer of Burnt Sienna, which is the base colour that I often use before painting. This will have to be left until it is dry, which with alkyd oils is about 12 hours. Other oil paints take longer, but you can also use acrylic paint as an under surface as long as you don't apply it thickly.

The colour of the ground will influence the final painting. In my examples I've painted the first surface with Terre Verte (right), which is a cool grey-green, the second with Burnt Sienna (top of facing page), and the last with a dark colour made by mixing French Ultramarine and Burnt Umber (bottom of facing page). So one has a cool background, the next a warmer background and the last a very dark background.

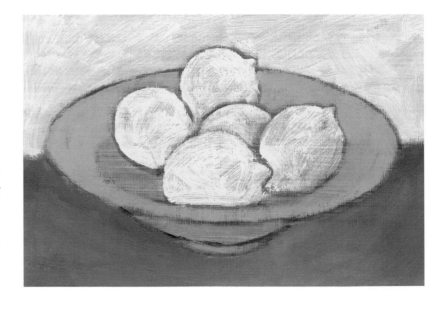

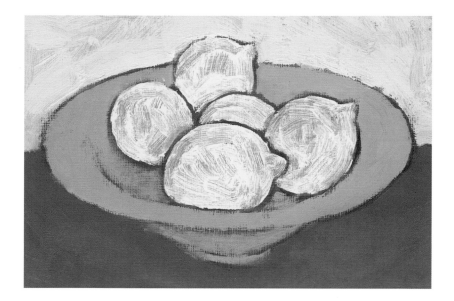

Once the base colour had dried I painted my still-life of five lemons in a green bowl, first outlining the shapes in a dark tone, then blocking in the main colours with quite thick paint. I used exactly the same colours for all three versions. These are not the finished paintings – just the first attempt to show the colours of the objects correctly.

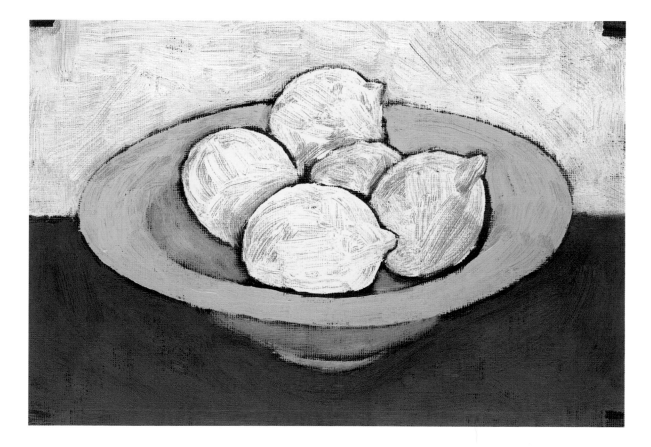

What is immediately noticeable is that the three pictures are all subtly different: the first looks rather cool in colour, the second is much warmer, and the third appears more luminous. This is due to the background colours, which show through the paint and give a particular look to the picture. So from the word go you can influence the look of your painting by the ground colour you choose.

Of course to finish the paintings, I would put on more layers of paint and start to show more detail, which would have the effect of diminishing some of the intensity of the base colour. This means that eventually the three pictures would become more similar, but the base colour would still have a subtle effect on the final result.

Drawing With The Brush

Once I have laid a ground I then draw on it an outline of the
scene I plan to paint, using a brush – most frequently a small
hog's bristle brush. At this stage I try to get all the main shapes
in proportion and in the right place on the canvas. I can then
start painting immediately on to the framework that is there in
my simple drawing.

40

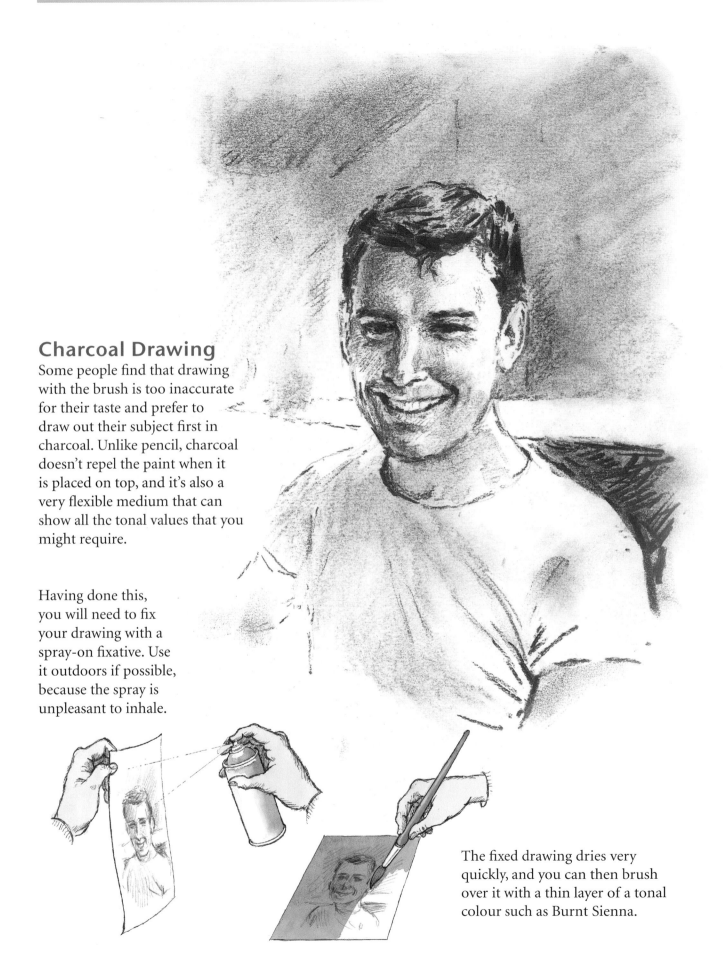

Charcoal Drawing

Some people find that drawing with the brush is too inaccurate for their taste and prefer to draw out their subject first in charcoal. Unlike pencil, charcoal doesn't repel the paint when it is placed on top, and it's also a very flexible medium that can show all the tonal values that you might require.

Having done this, you will need to fix your drawing with a spray-on fixative. Use it outdoors if possible, because the spray is unpleasant to inhale.

The fixed drawing dries very quickly, and you can then brush over it with a thin layer of a tonal colour such as Burnt Sienna.

41

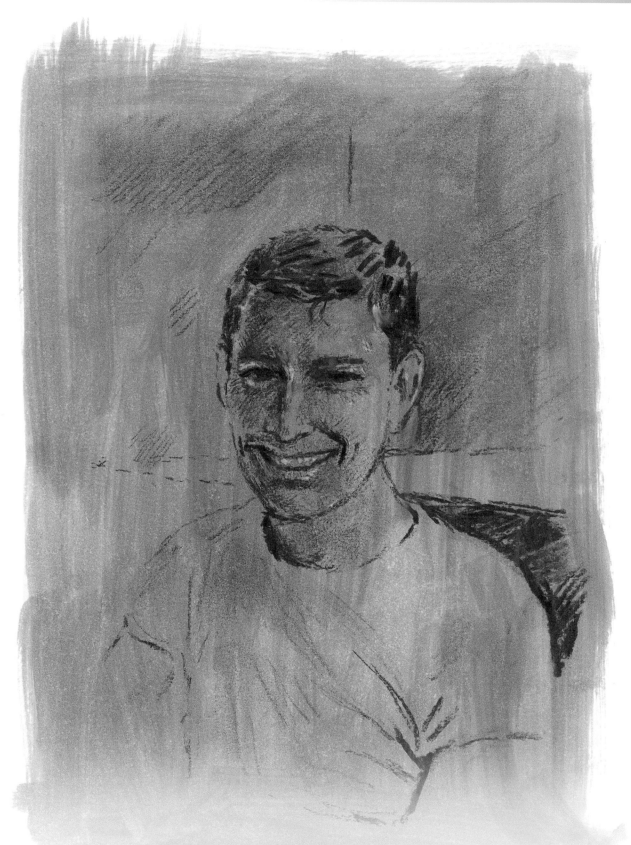

Once the ground is dry you will be ready to paint all your colours on to a complete drawing. This is a good way to start, though with time and experience you may discover your own preferred way of working. For example, I know a painter who always draws her subjects in great detail with charcoal then squeegees a layer of French polish across the drawing, which gives her a pleasing shadowy tonal and fixed surface to paint on.

Underpainting

A traditional but very painstaking way to prepare for your painting is to render the whole subject in Terre Verte, which is a soft greyish-green, and show it in complete detail, building up the colour until you have a tonal drawing in paint. This will have to be completely dry before you can start the painting properly.

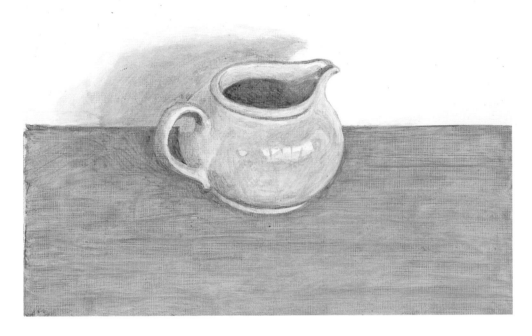

The time spent in developing your work is one of the reasons that an oil painting can take some while to complete. Quite often the tonal painting is then covered by a translucent layer of colour, usually in an opposite colour value, such as Burnt Sienna.

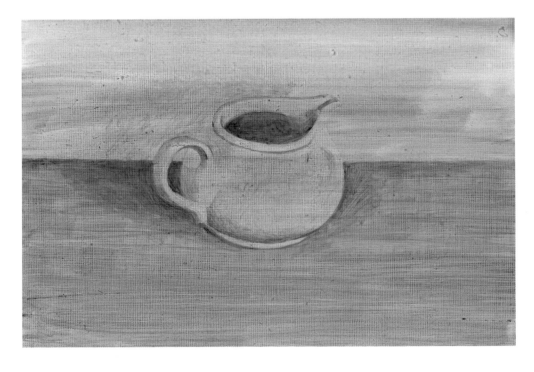

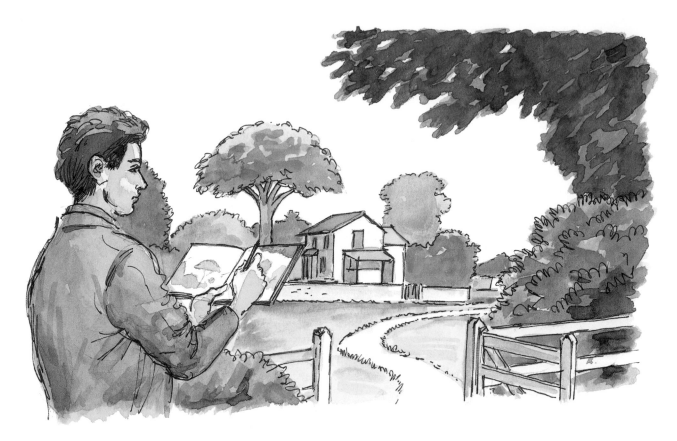

Squaring Up

When you go out to paint on location, always consider the possibility that you may want to produce a larger painting of the same scene at home afterwards. This means that you must think about how much information you should put into your on-location work to make a larger painting successful; it may be necessary to do more than one version of the smaller picture and some extra drawing and painting too.

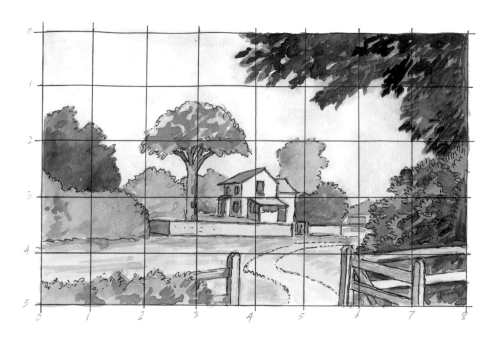

Let us assume that you have returned from your outdoor expedition with a couple of small paintings and drawings as information. You need first to square up the piece of work that you are going to base the bigger painting on. Decide how large your squares must be to make an adequate grid to cover the painting. In the example shown there are five squares top to bottom and eight squares from side to side – 40 squares in all. This, in the format of the picture shown, is an adequate grid to work with.

Next, transfer the image to a larger format. Begin by drawing the grid much enlarged on to the canvas but in the same proportion, that is, five squares deep and eight squares from side to side. Carefully copy the outline of all the shapes square by square until you have a recognizable outline drawing of your scene on the canvas, then start to paint in all the colours as closely as possible to those you recorded in your sketches. This is where your memory will also start to help you to reconstruct the look and feel of the scene. It's quite an exercise to make the picture look as natural as possible from your sketches – be careful not to tidy up areas of the scene too much, which is tempting when working on a larger scale.

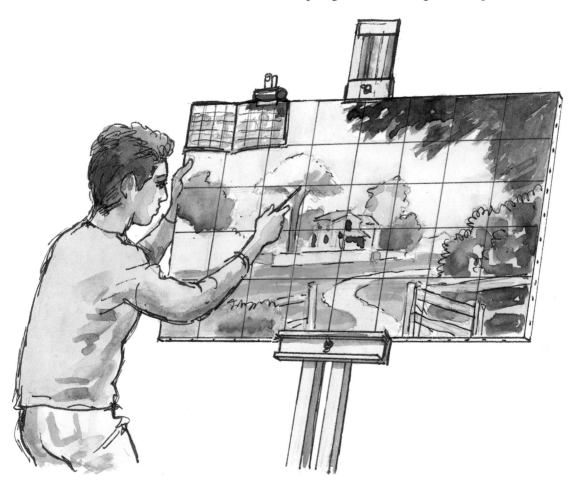

To demonstrate how this works I've shown the painting almost finished with the squares still showing, but of course as you paint over the grid it will gradually disappear. Notice how the original squared-up picture is attached to the canvas, though usually that will only be there during the first stages.

After you've completed your picture to the best of your ability, it's a good idea to go and have another look at the location to see if what you have produced has something of the real scene about it. It doesn't matter if you haven't got everything in the painting, as long as there is at least one of the qualities that led you to want to paint the location in the first place. If it has several, you are doing very well. If you painted the scene again some time, you would find it quite new, and you would see a lot more than before. This is part of the fun of painting; subjects never become boring.

45

THE APPLICATION OF PAINT

There are many ways of applying paint to get the effects you want in your pictures. Mainly, of course, it's just a matter of laying on the paint with a brush and trying to show what you want to express as clearly as possible, but there are quite a few technical terms for the various methods of doing this that you may come across in your reading or when you're talking about painting with other artists. Here are some of them.

Wet On Wet

Laying paint over or next to a colour that isn't yet dry is referred to as painting wet on wet. On the left of my example I put down a mixture of French Ultramarine, Cadmium Orange and Titanium White; on the right, a mixture of Dioxazine Purple, Cadmium Yellow Light and Titanium White. In the middle section I painted a mixture of Cadmium Red Pale, Permanent Green Light and Titanium White, allowing it to mix in with the colours on either side so that I achieved a gentle gradation from one tonal colour to the next.

If at first you aren't able to get this effect successfully, don't worry – you'll be learning all the time how the colours blend with each other. The oil medium is slightly more difficult than some others at the outset but soon gets easier through practice and eventually is one of the easiest ways to produce really subtle work.

Blue/Orange/White	Red/Green/White	Purple/Yellow/White

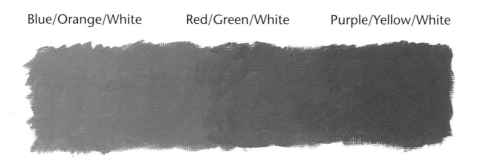

Wet On Dry

Painting wet on dry means allowing the first layer of paint to dry before you paint over it with another colour. I put down a mix of French Ultramarine, Cadmium Orange and Titanium White on the left and Cadmium Red, Permanent Green Light and Titanium White on the right.

When these were both quite dry I painted the opposite mixtures of colours over the top of the base colours, brushing them out and allowing the under colour to show through a bit. This gives you another way of changing the look of colours by applying any number of successive layers.

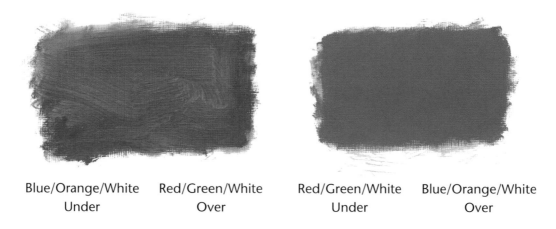

Blue/Orange/White Under	Red/Green/White Over	Red/Green/White Under	Blue/Orange/White Over

Dry Brush

This simply refers to painting with the pigment on your brush as dry as possible, giving the impression of a stroke with a chalk or crayon. It is achieved by making sure that the paint you are using is not loaded with oil – if need be, brush out the paint a bit on another surface first.

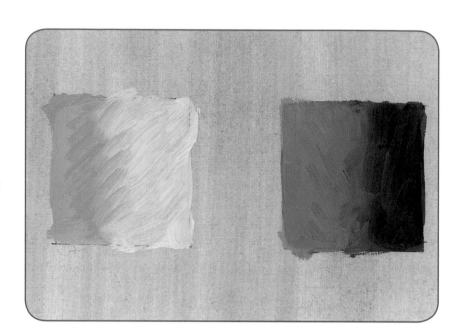

Blending

When you are working on wet paint, you can deliberately blend two colours together where they meet. It is quite a tricky process and you will need to try it out several times before you are successful. As you get more practised, you will find that you can use smaller and smaller brushes to get more subtle blendings.

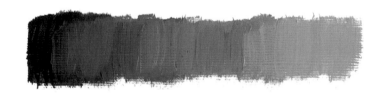

Reducing A Colour

Often you'll reduce colours by mixing them on your palette; on other occasions you may want to do this as part of your painting. Here I've put a strong blue, red and yellow on the surface and then, with the addition of white, gradually reduced their intensity until they are very pale. You'll find it quite tricky at first to get the gradation of tone smooth, but with a little practice you will soon perfect it.

Glazes

Sometimes you'll want to adjust a tone or colour that you have already laid down. One way to do this is by painting a glaze of diluted colour over the top that leaves the original colour still visible, thus creating a new colour or tone.

To do this effectively, make sure that the underpainting is dry – if it's still wet the new layer of paint will pick up a lot of the original colour and instead of a glaze you'll have a mix of the two colours, which won't look the same. The glazing colour must be diluted sufficiently with a medium to avoid it obliterating the underpainting. It's safest to use a glazing medium for this, as just reducing the colour with turpentine may cause cracking later if the undercoat is much thicker. Alternatively, you can use linseed oil, though this takes longer to dry than glazing medium.

In the example shown here the under colour is a thinned-down Burnt Sienna with a thin layer of Terre Verte painted over it. As you can see, the colour of the Burnt Sienna shows through the Terre Verte to create a cooler version of the original. This technique is not difficult but will require a bit of practice before you become good at it.

Impasto

When you work in oils you will usually put on the paint in a fairly solid way so that the underlying surface is obscured. In the technique known as impasto, the paint is applied so thickly that it shows the marks of the brush or palette knife and may even take on a sculptural, three-dimensional quality. It's an excellent way of adding vigour, texture and expressiveness to your paintings.

Scumbling

This term describes a way of putting a thin layer of colour over another by pushing your bristle brush around the surface of the canvas, allowing some parts of the undercolour to show through. It creates a sort of smoky effect and is useful for textures that you will need for painting landscapes in particular. In my example the under and upper colours are both Burnt Sienna, but you can see how the tonality changes.

Tonking

This term comes from a technique that the British painter Henry Tonks (1862–1937) developed to reduce the thickness of his painted surface so that he could then work over it further. When he had taken his painting to a stage where the paint was thick and still wet, he would lay a large sheet of newsprint across the surface, smooth it down and then carefully peel it off again. This had the effect of taking off a thin top layer of paint in a patchy way, giving an impressionistic, broken look to the surface, which he could use to soften his more hard-edged work and create more atmosphere.

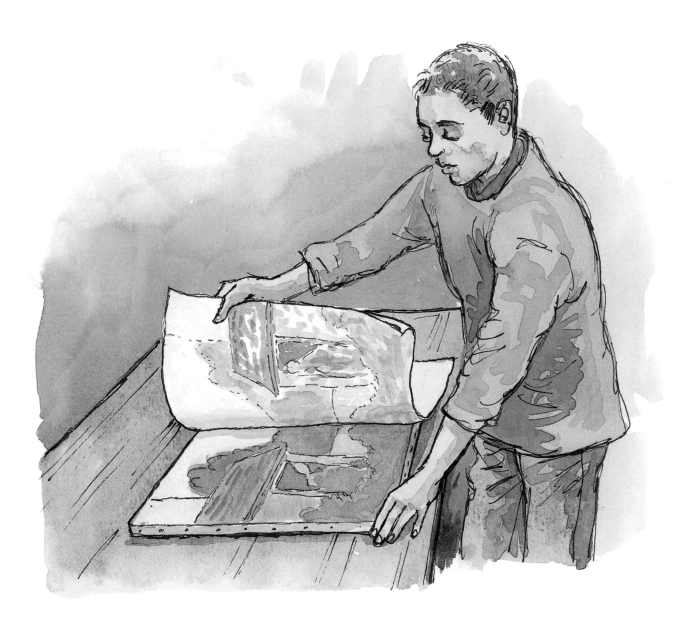

Some painters use newsprint, others blotting paper or paper towels, and if you want to experiment with different papers you might find you can produce interesting results. The longer you leave your painting to dry, the more subtle the effect of the tonking will be.

Palette Knife Painting

Some painters don't like the highly controlled effect of the brushwork that most artists use and prefer to put on the paint with a palette knife instead. This requires a slightly different approach to painting and creates a more impressionistic result in the paint surface.

Palette knives come in a range of sizes and shapes; the small ones have quite sharp points to them, allowing you to make fine marks if you wish to. They tend to produce hard-edged marks, but you can reduce these by scraping them with the point or edge of the tool. In the example shown I have used some French Ultramarine with Titanium White but have not totally mixed the colours, so that the darker blue and the paler white show up as well as the mid-tone.

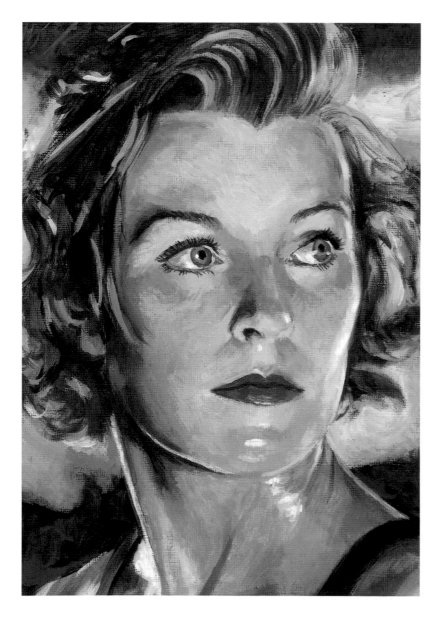

Portrait In Brushwork And Palette Knife

The first portrait is fairly conventional, painted with brushes of varying size and thickness. As you can see, the edges can be sharp and defined or soft and smoky. It's a method that you can take to the most photographic style of reality, depending on your skill and the desire to paint in every detail.

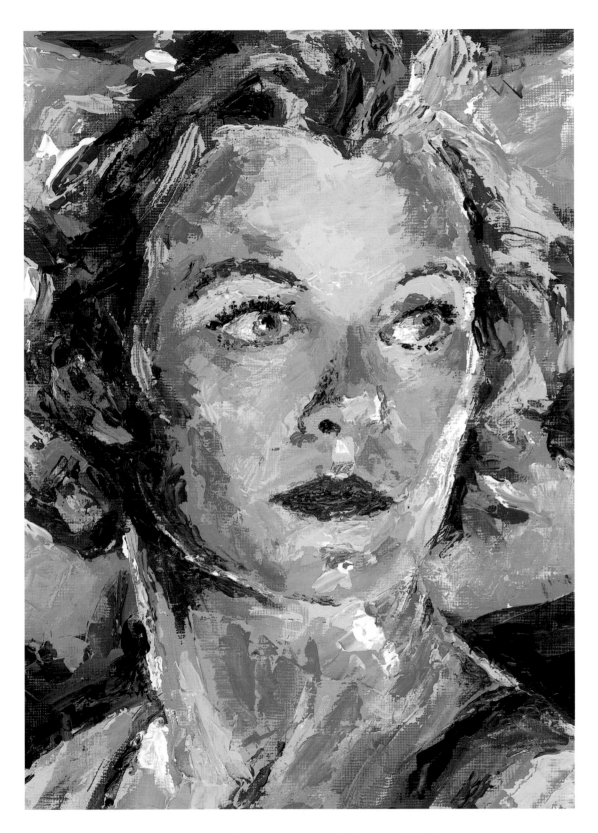

The second portrait is painted in the same size, with the same lighting, pose and background, but as you can see the effect is rather different. Here, no matter how much I might work the paint, it will never have quite the same effect as the brushwork. If the painting were a lot larger the broken effect of the surface would be less apparent, but at this size part of the charm of the work is the obvious texture.

CHAPTER 3

STILL LIFE

This section of the book leads you into the easiest genre of painting for a beginner to tackle – though that's not to say that it can't be the most powerful type of painting. In still life, you decide exactly what objects you want to paint, and once your arrangement is placed in position you can take your time; only if you include flowers do you impose a time limit on your work, but it takes a while before they fade and die. Unlike the subjects of figure studies, still life objects don't need to take a break, and unlike landscapes they're not usually affected by the weather.

This exploration of still life starts with one object and gradually introduces others, so that your compositions become more challenging as your skills increase. We shall look at some of the objects that you can combine to make an interesting display, and your still lifes may be as complex as you like. However, it's always best at first to work on the basis that less is more, so that you can really concentrate on painting one or two objects well rather than tackling myriad items in a complicated display. Eventually you can add as many as you're prepared to paint, as long as you have the space to keep them in the same position for long enough.

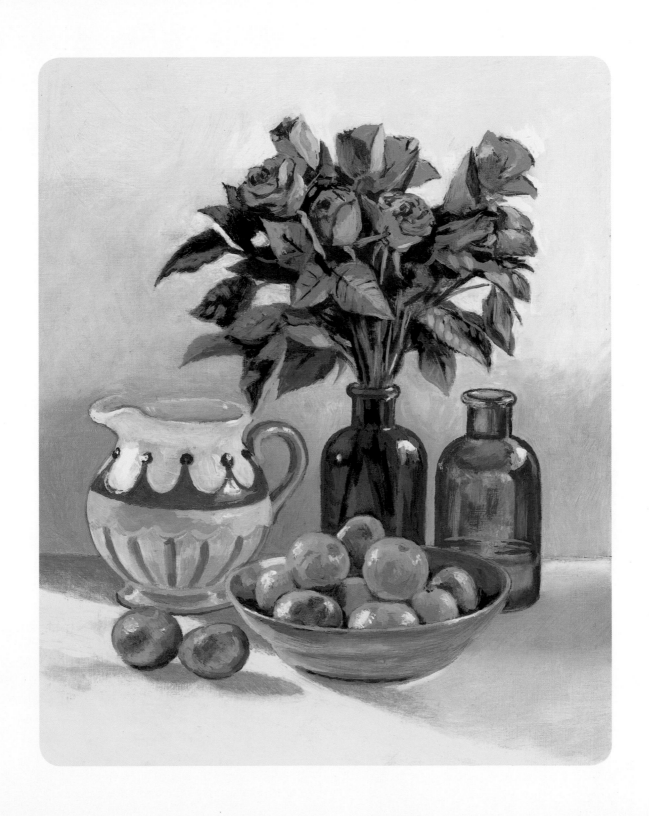

PAINTING A PEAR

To start with, just choose a piece of fruit and paint that against a very simple background. As an example, I have taken a large, ripe pear standing upright on a dark surface against a neutral background.

Stage 1

The first step is to draw the shape as accurately as you can. I prepared the canvas with a thin layer of Burnt Sienna and used a brush to draw a strong line in the same colour. The undercolour makes it possible to work on a tone rather than try to match colours on a bright white surface.

If you are worried about painting straight on to the canvas at first, make a careful pencil drawing and then trace it on to the canvas once you are satisfied that it is the right shape.

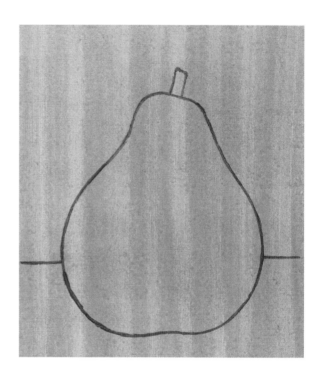

Stage 2

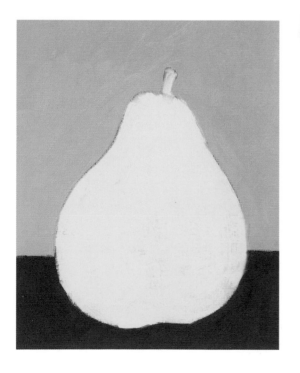

The next stage is easy enough, too; it's just a matter of putting down a colour that gives a good general idea of the object without any influence caused by shadows or reflections. This is called the local colour. It's always advisable to put in colours simply at first because you can get a better idea of how the relative tones of the main ones react with each other.

In this case the background is a medium neutral grey made from French Ultramarine mixed with a little Naples Yellow and reduced with Titanium White, and the surface the pear is standing on is Burnt Umber. The pear itself is coloured with Cadmium Yellow Light mixed with a touch of Burnt Sienna and reduced just a little with Titanium White. I laid all these colours on quite solidly but allowed just a little of the undercoat to show through.

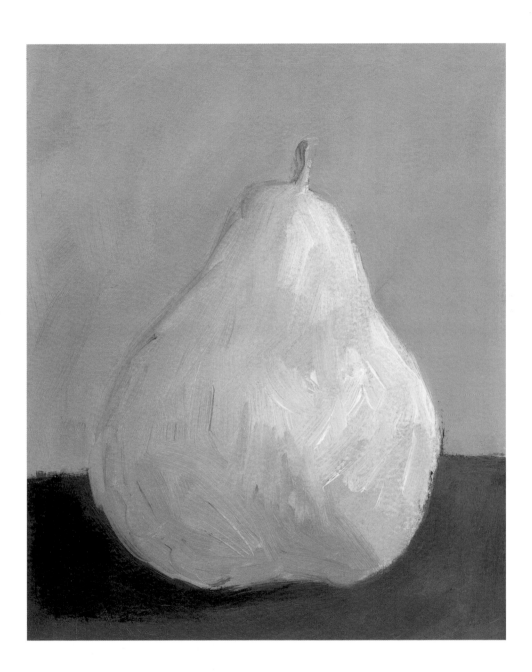

Stage 3

Next I added some tonal values to indicate the shape of the pear. A little Titanium White with some Viridian and a touch of Burnt Umber gave me the shadow on the pear, faded off from left to right. Then, with additional French Ultramarine, I put in the shadow cast on the wall behind, and with some French Ultramarine and Burnt Umber the dark shadow cast on the table by the pear. At this stage you may want to paint the areas where there's stronger light with the original colours, but this time mixed with a little Titanium White.

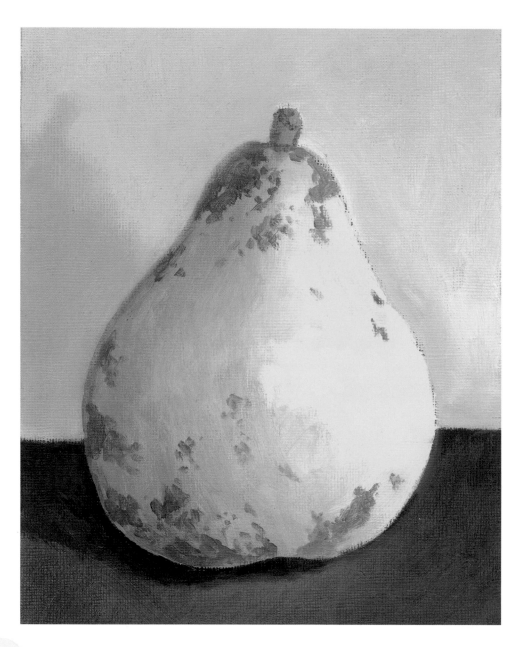

Stage 4

I began building up the tonal values on the surface of the pear to form its rounded shape, using a thin layer of greenish-brown made from Viridian mixed with some Burnt Sienna and a little Titanium White. I kept this thin so that the yellow showed through easily and made it slightly darker on the left side of the pear than on the right. On areas where the light struck the pear most strongly I avoided adding any tone.

Then I began to put on the darker browner marks that the surface of the pear was speckled with. For this I used Burnt Sienna mixed with a little Naples Yellow, darkening the brown with a little Burnt Umber on the shaded side. To show where the strongest light fell, I put down some Cadmium Yellow heavily reduced with Titanium White. I also worked on the tonal variations in the background, adding a lighter version of the original neutral grey for the background and a mixture of Burnt Umber and Burnt Sienna for the lighter areas on the table top.

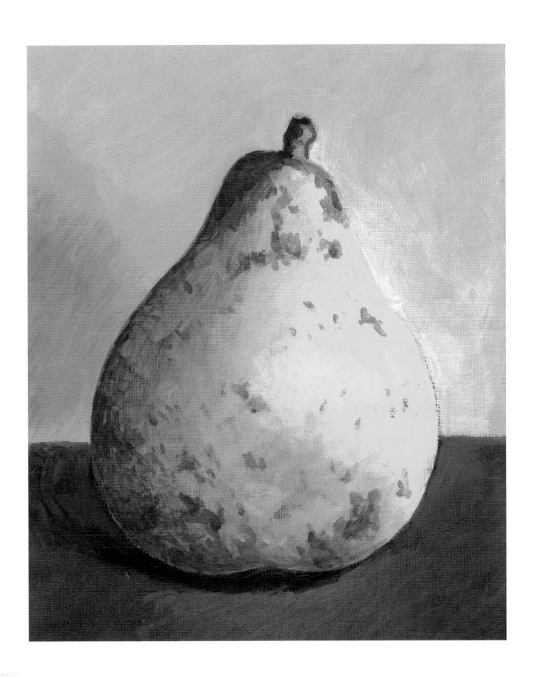

Stage 5

Now for the final stage, during which I looked very closely at the subtle tonal changes on the surfaces and softened the edges of the shapes or made them crisper where needed. I also worked on the details such as the stalk and the marks on the surface of the pear. The shadow closest to the base of the pear needed to be strengthened and I built up the whole area of shading a little, taking care not to overdo it. Little spots of green and brown speckled across the surface of the pear gave the effect of the skin.

At this stage stepping back from the picture is important, and you may often spend more time looking at your work than actually painting it. This is all to the good, though, because your judgement at this stage will make the difference between a piece of work you can be pleased with and one that falls short of your own standards. Time spent checking each detail is time well spent.

A NEW CHALLENGE: GLASS JUG

For the next exercise of painting a single object, I have chosen a glass jug. The nice thing about a glass object is that you can see right through it, so if you place it on a neutral surface with an equally neutral background wall, the colours will be simplified – in fact it will almost be a tonal painting. This is good practice for getting tonal values right.

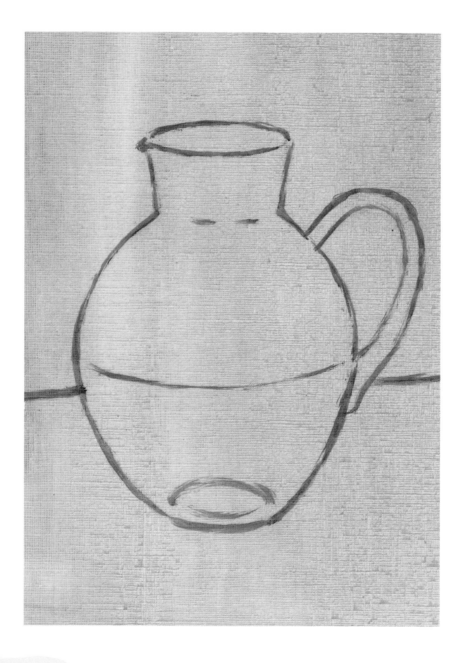

Stage 1

As before, I began by drawing the outline of the object on my prepared canvas.

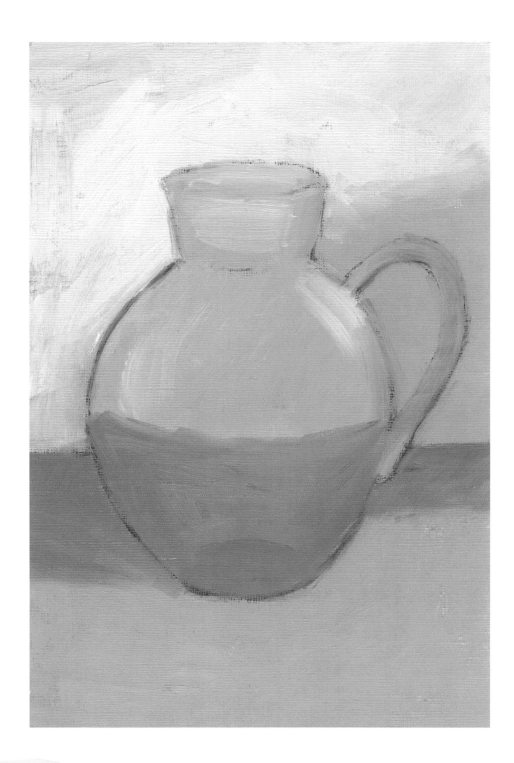

Stage 2

Notice how the part of the background and surface seen through the glass is slightly greener and darker than the background seen beyond. I put in the cast shadow on the wall behind and an indication of the lightest part on the glass surface. The colours used so far are Naples Yellow, Viridian, Burnt Umber, Titanium White and French Ultramarine.

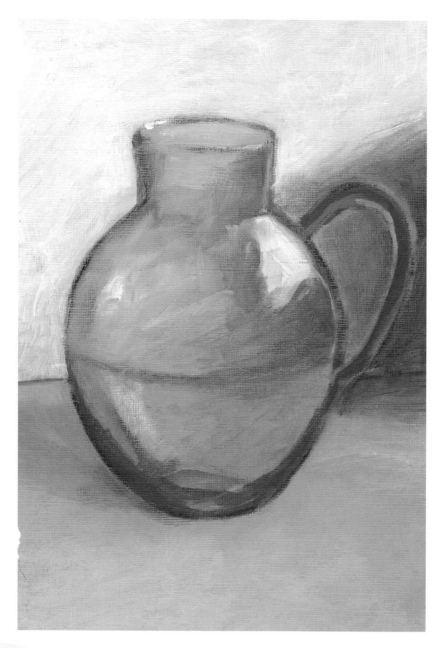

Stage 3

Now you can start to build the definition of the rounded jug with darker and lighter versions of the colours that you have already used. I first lightened the background wall, graduating it from the top downwards and strengthening the shadow cast on the wall. Then I put in the shape of the outline of the jug in strong green tones, adding a little brown and white to give the lighter and darker edges. Notice how the base and the handle of the jug have much thicker glass and so look much greener than the rest.

I also lightened areas around the top of the jug, and then the surface it was standing on. The cast shadow on the wall shows through the glass as well, so that side of the jug has a darker tone. The exception to this is where the strongest light strikes the rounded surface of the jug, which is much lighter than anywhere else.

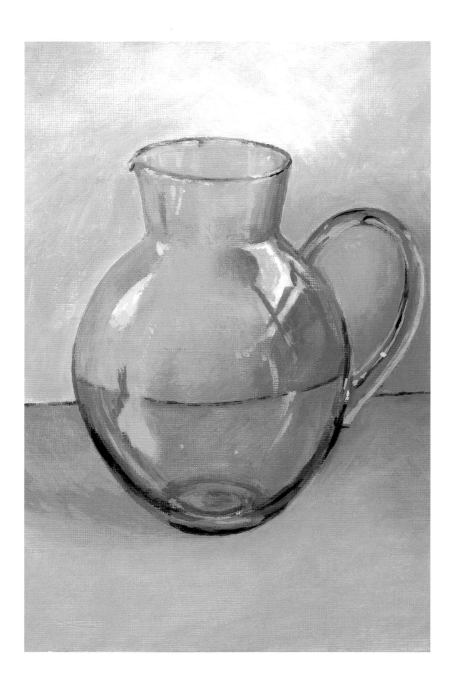

Stage 4

Now comes the point where you will have to see exactly how far you can take this painting. My colour range here is quite limited, which is an advantage, but surfaces that are very reflective often show the influence of colours from surrounding objects.

Observe very closely the myriad reflections on the surface of the jug, both dark and light. It doesn't matter if you leave some of them out – there are many tiny points of light reflected in glass and it's your choice as to how many of them you actually put in. You will need to include enough for the jug to look glassy, like I have, but some of them can be ignored if you prefer.

The last but most important thing to observe is where the very darkest and lightest tones are – it's the range of contrast between these that makes the object look convincingly like glass. Make sure that the cast shadows on the wall and the tabletop are not too powerful and the relative tones and colours of the background are right –the part seen through the glass is usually darker in tone than the rest, but only slightly. It is often bluer or greener too.

A MORE COMPLEX STILL LIFE

This next still life is a little more testing, in that it contains multiple objects. The setting is a tabletop with a pale green background lit from the left, and on the table is a bowl containing a lemon and a lime, with a fir cone lying alongside it. I needed to position the objects to get the best out of the arrangement and concluded that the lemon should be more prominent in the bowl than the lime, and that the fir cone would be to the left against the lightest part of the table surface.

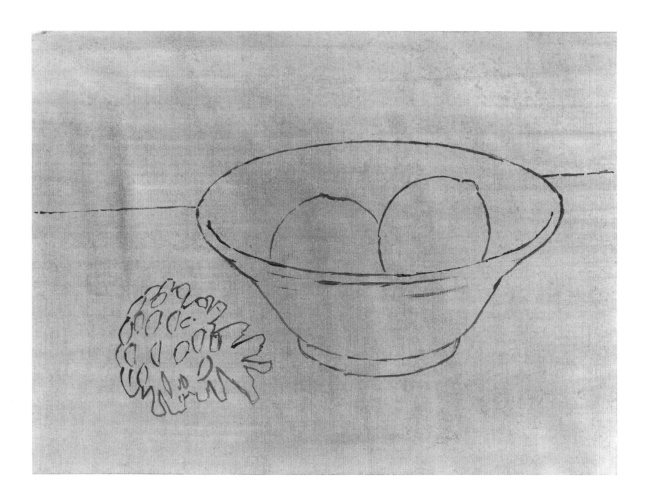

Stage 1

Your biggest challenge when drawing the composition is the ellipse of the edge of the bowl – if it's not drawn well it will really affect the success of the picture, so that's the thing you'll need to consider most carefully.

The fir cone is complicated, too, because of the way the spines rotate around the centre. The easiest viewpoint is from the side, where the pattern is less critical – if you want a bigger test, try drawing it with the top end facing you.

Stage 2

At this stage, put in the local colour quite simply. For the background, I used Cadmium Lemon with a touch of Viridian reduced with Titanium White; for the table some Naples Yellow with a touch of Burnt Sienna; for the lemon Cadmium Lemon, and for the lime the same colour with the addition of some Viridian. To paint the bowl I mixed some Burnt Sienna with Viridian, and the fir cone is Burnt Umber. None of these colours were put on heavily, because thicker paint was to be added later on.

Stage 3

I made the background wall much greener towards the shadowed part and yellower towards the light. Similarly, the lighting has provided cast shadows to the right of the bowl and the fir cone on the tabletop. I blocked in some darker green tone on the surface of the fruit and also put in some very dark tones to show the structure of the fir cone. I then picked out the strongest highlights on the bowl and the fruit.

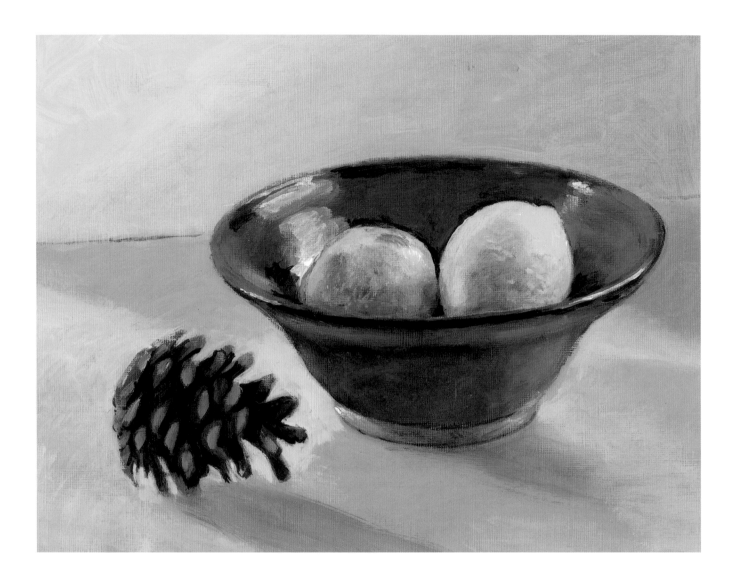

Stage 4

The next step is to really discover the range of tones and colour in the objects and show the more subtle aspects of their gradation. The bowl has some nice green lighter areas on the inside and warmer reflections on the outside from the tabletop. I made the lighter areas of the lemon brighter and the shaded parts slightly warmer in colour – the lemon is still basically a green-yellow, but the deeper shadows have a warmth about them that comes from a purple or a reddish brown made from a mix of Dioxazine Purple and Burnt Sienna, plus a tiny amount of Naples Yellow and Titanium White. The lime received similar treatment.

I painted the inner surface of the bowl and its outer rim very blue in its darkest areas, then put in the very bright highlights on the edge of the rim and in the main area of light. The cone needed to be defined more clearly, with darker and lighter tones of the brown that I had already applied, and this was also useful for the bottom edge of the bowl, which is unglazed. At the end of this stage I had an effective three-dimensional picture, but it still lacked refinement.

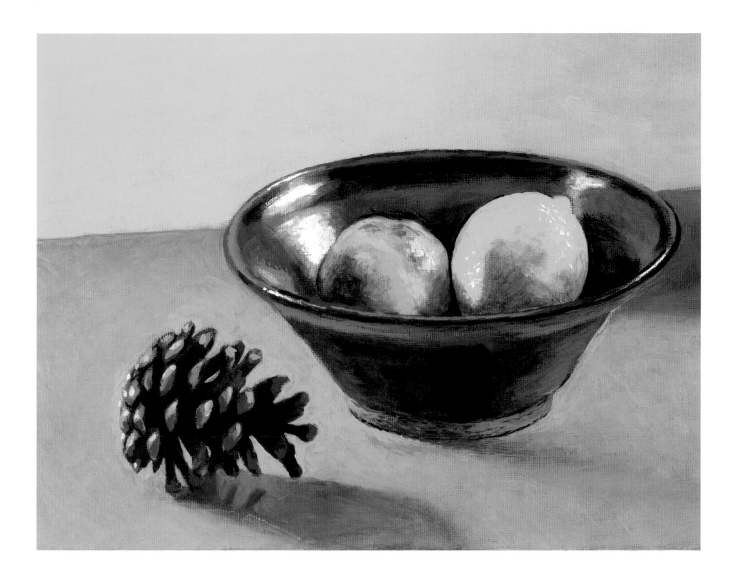

Stage 5

The last stage always requires great care and frequent stepping back to check what else might need to be done or, conversely, whether you are starting to spoil your picture by doing too much. I harmonized the background tones and colours so that the effect of light and shade looks more realistic, then defined all the edges of the objects more exactly so that the shapes work for the picture as a whole. After that I gave the colours more subtle qualities by the careful additions of tone and colour, taking great care over the surface of the fruit in particular because these are probably the most eye-catching parts of the picture. Finally, I also looked closely at the silhouette of the cone to make sure it had the right angular sharpness.

A THEMED STILL LIFE

This next piece of work is a much more ambitious project, for which you take a theme, in this case travelling, and put together items that relate to it. The objects I gathered are a coat, a large travel bag and a pair of sturdy boots. The bag takes up most of the space and the coat is thrown across behind it, while the boots are placed just to the front. All are similar in colour, being variations on brown, beige and sand. This means that the colours are in close harmony, so you will be almost painting a monochrome picture, with the tonal values being the strong point.

Stage 1

Because this is a more complex still life, I suggest that you draw your composition in pencil first, making it about the same size as your painting will be and getting all your correcting and erasing done at this stage. Although I would probably just start painting directly, I have had a few years of solid work in this medium and have the confidence that it brings. A successful drawing will give you the confidence that you can also make a good painting.

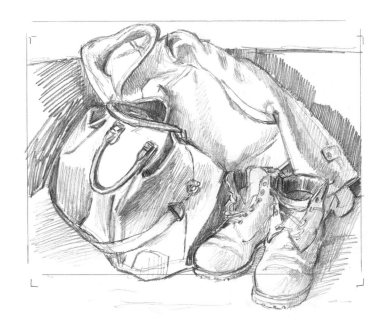

Stage 2

When you have got a pencil drawing that you are satisfied with, trace it off and transfer the shapes to your canvas as exactly as you can. You will only need to draw the outlines of the shapes, because you will have the drawing to refer to when you paint. On the prepared canvas, make an outline drawing in paint by simply painting over the lines you have transferred on to your canvas.

Stage 3

As the painting is going to be so close in colour values, the next step is to make sure that the tonal value of each part is well seen, especially in the boots and coat, which are very close in colour. The dark background helps to anchor the shapes in the picture and the dark leather bag makes a strong, solid shape in the mid-left space.

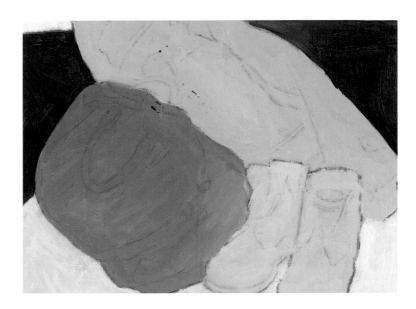

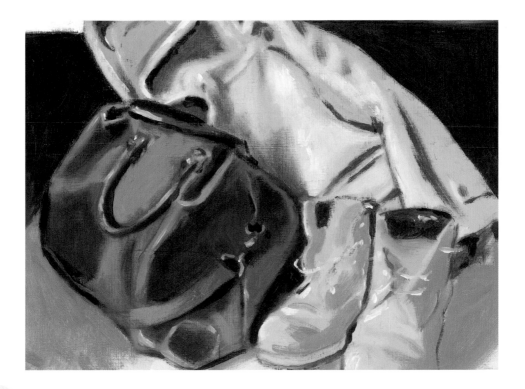

Stage 4

Now comes the main part of the painting, where different colours and tones are built up to bring the dimensions of the composition to life. To get maximum contrast in the darker tones, I used French Ultramarine, which, combined with Burnt Umber, gives a very dark tone, almost black, but with more vibrancy. The softness of the coat is in contrast with the solidity of the boots, the bag being somewhat in between in terms of rigidity.

The highlights are also important at this stage, especially the brightest ones on the handles of the leather bag and on the tops of the boots. You can either put them all in at the same intensity and then later tone down all but the brightest with a wash of colour over the top, or you can endeavour to put them in immediately at the correct intensity, mixing some colour with each one as you assess it.

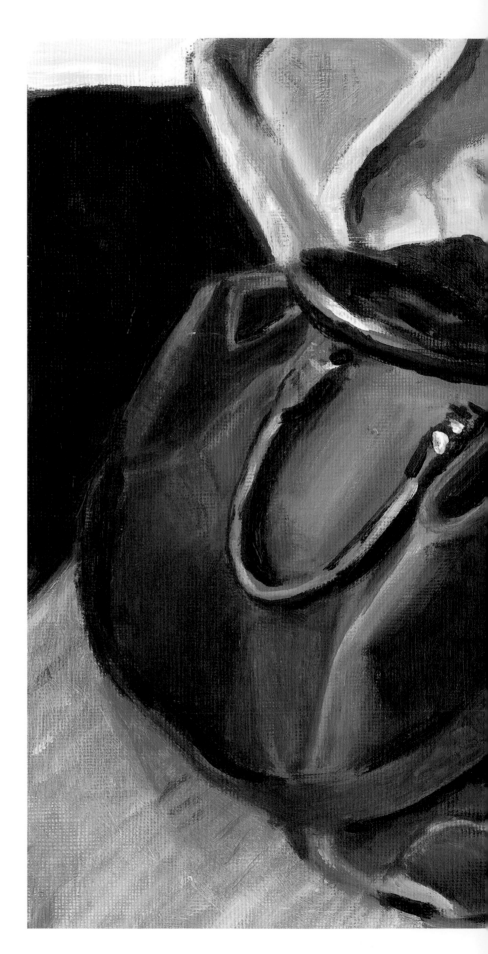

Stage 5

At this point the main thing is the careful study of the whole picture to identify which parts need more work and if anything needs altering. I defined the dark shadows on the bag and around the boots and put in cooler blueish tones on the front of the bag and shadows on the duffle coat. I also worked on all the details on the boots, bag and duffle coat with lighter or darker touches of paint, carefully mixed to get the right tone and colour. They were all the colours used earlier, but each mark might be in a slightly different combination of them.

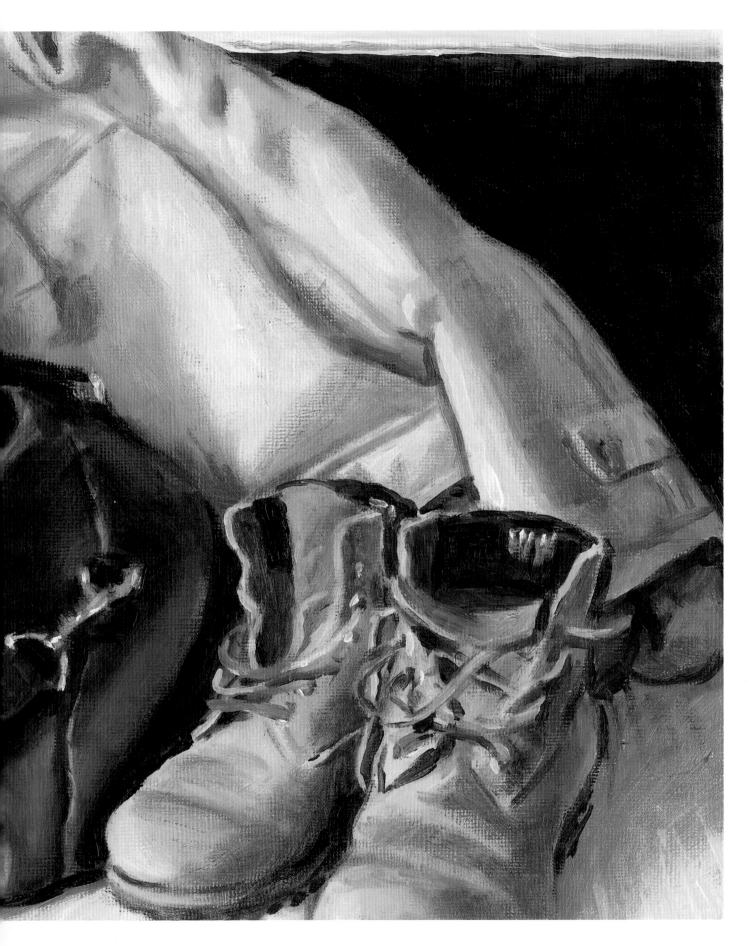

FOOD AS A THEME

The next composition is of an arrangement of food set out for a simple meal. On the breadboard there's a knife and a loaf of bread with a slice already cut. Nearby is a plate with some cheese and at the rear is a glass jug of milk with two lettuces beside it; in the foreground are two large onions. The colours are fairly neutral, with the greens and rich Burnt Sienna of the browns being the strongest colours and tones. All the elements of the still life are very close together, making a strong, tight pattern.

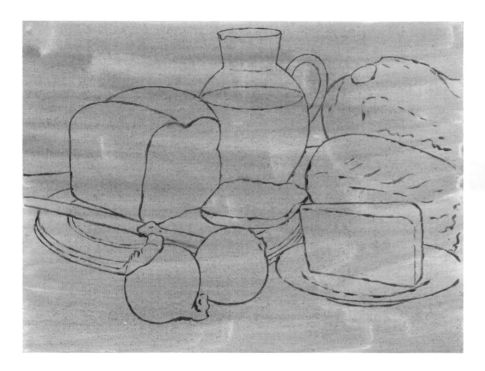

STAGE 1

The first stage was just to draw the outlines of all the objects as carefully as possible to get the right shapes and sizes, using Burnt Sienna on a paler ground of the same colour.

STAGE 2

Next I put in Burnt Sienna for the browns, Naples Yellow for the yellows, and French Ultramarine and Titanium White for the blues and greys. The green is a mixture of Viridian, Cadmium Yellow Light and Titanium White.

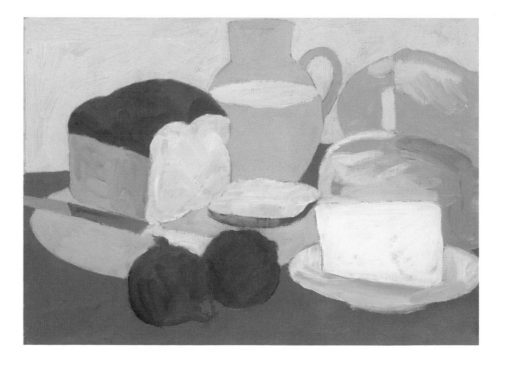

STAGE 3

Then came the stage where I needed to put in all the main details of the textures of the food. I mainly used a mix of the same colours, with the addition of some Burnt Umber to help darken some of the tones.

STAGE 4

(on next page) Once I had put in the basic textures and tones I built up the more careful and precise details and added the highlights and darkest shadows to give interesting contrast of tone.

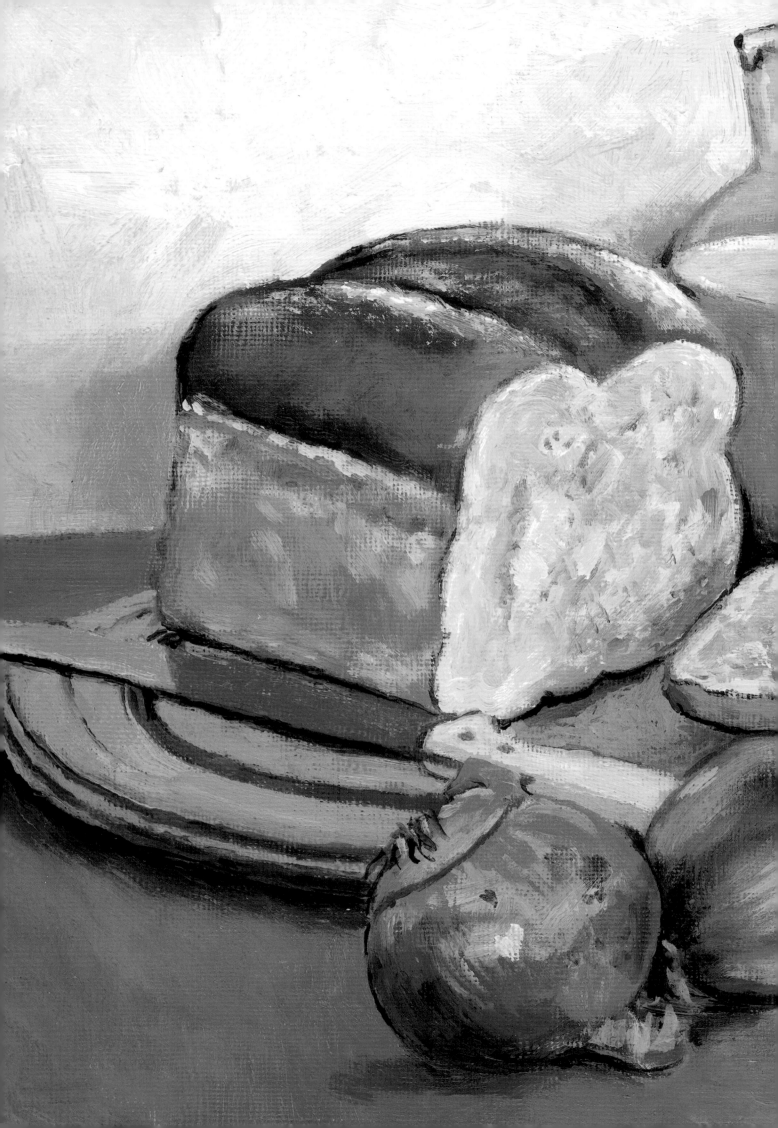

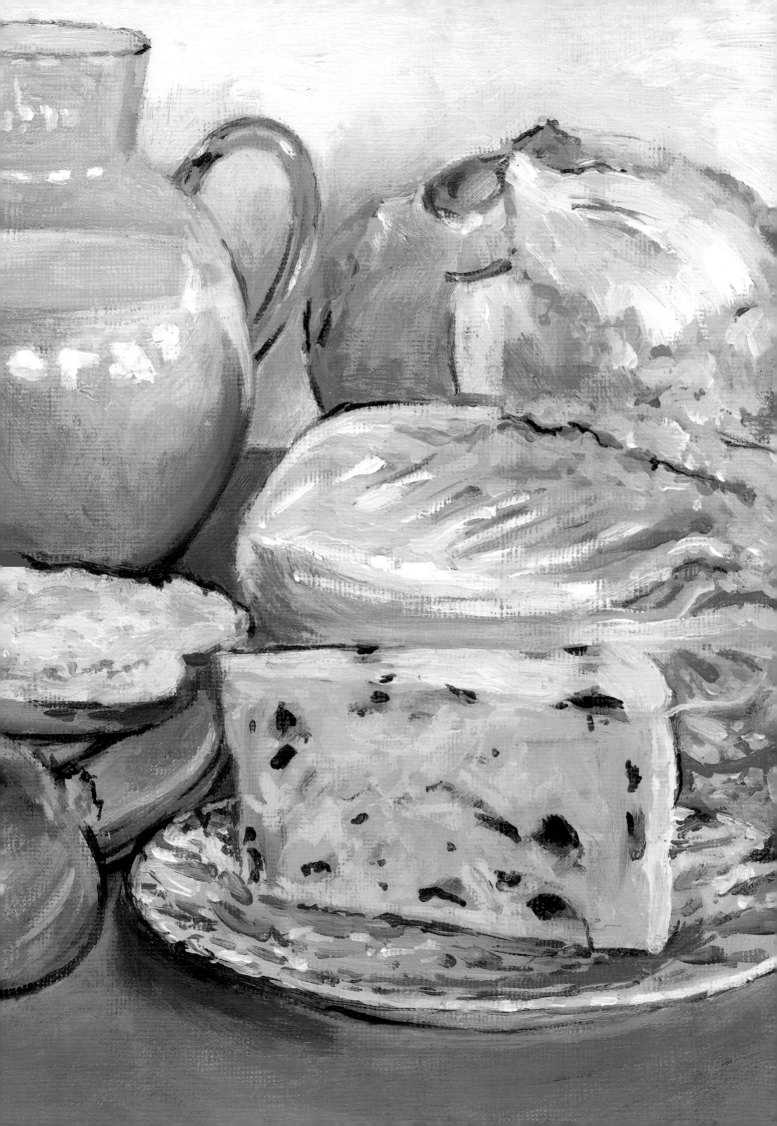

A COLOURFUL COMPOSITION

In contrast to the previous project, I have now chosen some very strongly hued objects to paint so that you can have some practice in using many more colours and making them harmonize. Next to a jug in yellow, blue, green, purple and red I put a green bowl full of bright orange mandarins, with a couple loose on the tabletop. The table is covered with a pale yellow cloth and the background is white. Behind the bowl I placed two glass bottles, one blue and the other purple, the latter containing pink roses.

The whole composition is a mix of many colours against a pale background. It can also be good to harmonize strongly coloured objects with a strong background colour – for example, when you have reds and blues, you might put them on a purple cloth, or in the case of orange and yellow you might choose a green background. Experiment with your colours to get the best effect.

Stage 1

As before, on a prepared ground draw in the whole composition with a brush using a dark neutral, such as brown. I have opted for my usual Burnt Sienna. You may want to draw the whole composition first in pencil or charcoal so that you can alter it until it is to your satisfaction. If so, you can trace it down on your prepared canvas as you did in the previous composition.

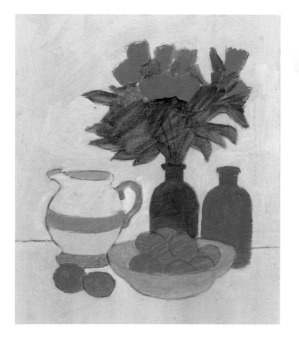

Stage 2

The next step is to put in the main local colours. For simplicity I put in the background first with Titanium White with a touch of French Ultramarine and Naples Yellow, and then the surface with white, Cadmium Lemon and a touch of Viridian. Then came the bowl in Viridian and Titanium White, with the mandarins in Cadmium Orange. The bottles were painted with French Ultramarine and white and Purple Lake and white; the flowers are Flesh Pink and the leaves Permanent Sap Green. From the top, the jug is a band of Lemon Yellow, another of Cadmium Orange, then Cadmium Lemon mixed with white, and at the base Cerulean Blue.

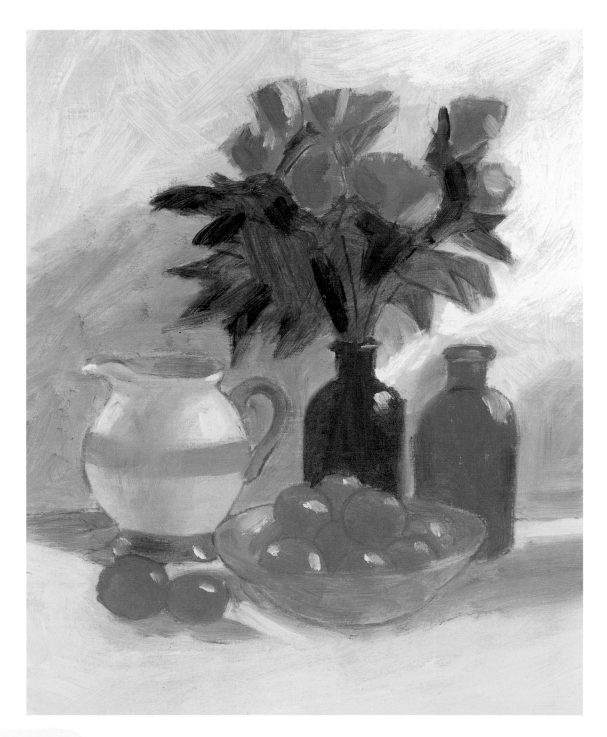

Stage 3

With the bright colours blocked in, I turned to the main areas of shadow, including those cast across the background. The shadows on the wall and roses are a mix of mainly Titanium White and a touch of Purple Lake and French Ultramarine. For shading the other objects I used the same mix but with some Viridian added and a bit more white to prevent them being too dark. On the foliage the shadows are Permanent Sap Green and French Ultramarine to strengthen it. Then, just with a touch of white, I indicated where the main highlights were to appear. Don't overdo this, because it's only meant to be an indication that you will fill out more strongly later.

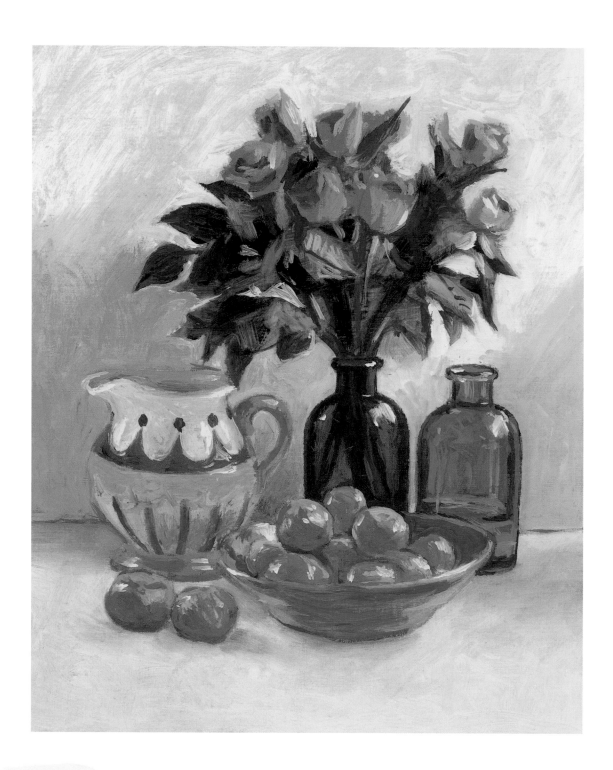

Stage 4

Next I worked on getting all the colours as correct as possible, including the darker and lighter versions of each object. The difference between the blue of the jug handle and of the glass bottle is a case in point – the former has more Cerulean Blue while the latter has more French Ultramarine. The purple glass bottle needed to be more blueish, having started off rather reddish. I added a softer pink to the roses and worked over the oranges with yellow and green tones and highlights of white and yellow, so that they aren't all exactly the same colour.

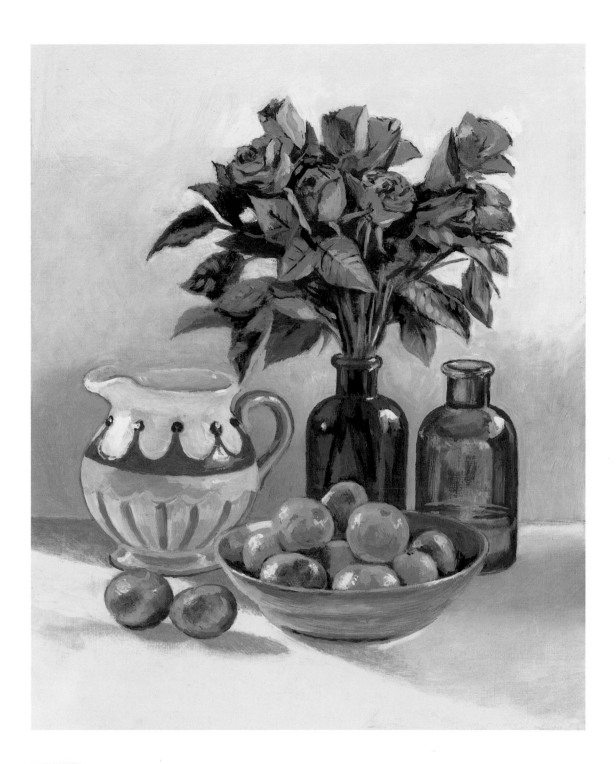

Stage 5

Now I spent a lot of time on each object, putting in each bit of colour and tone and sometimes making only minute marks with much smaller, pointed brushes. I found that at various points I had to lay thin coats of colour over what had already been done, in order to get the exact tone and colour that I could see. Sometimes I needed to soften the edges of objects and in other places I sharpened them up. One of the last tasks was to brighten or tone down the highlights and put in the very darkest tones on some of the shaded edges.

CHAPTER 4

LANDSCAPE PAINTING

The preparation that you need to make for landscape painting is rather different to that for still life because you'll be going out into the world to record some part of it that catches your fancy. Most outdoor painting is obviously done in summertime, but some artists love to paint snow scenes and rainy days as well; how determined you are to brave any weather that comes along when you're painting is a matter of personal choice.

Once you have sorted out suitable clothing for sun or storm, the next question is what you'll put your painting on while you're working on it. This is where you may want to use an easel, even if you have been able to get by without one at home. However, while a box easel is ideal (see page 20), even in the landscape it's possible to paint with fairly minimal kit to hold the canvas or board. If you have driven to the location you can just lean a board supporting your painting on some part of your vehicle, or if you have a portable seat you can rest the painting on a board on your knees.

Out in the landscape, the primary decision you have to make is just how much of what you can see you are actually going to paint. This can be tricky, as you have so many options. One way to narrow them is to make a paper or card frame to the same format as your canvas or board, hold it up in front of you and then move it around until you can see a section of landscape enclosed that looks to you like a good composition, remembering to consider how much sky you should include in relation to the land. Another way is to decide that a tree, a building or some other object will be at the edge of your painting, and this will help you to keep the sense of the whole picture in mind.

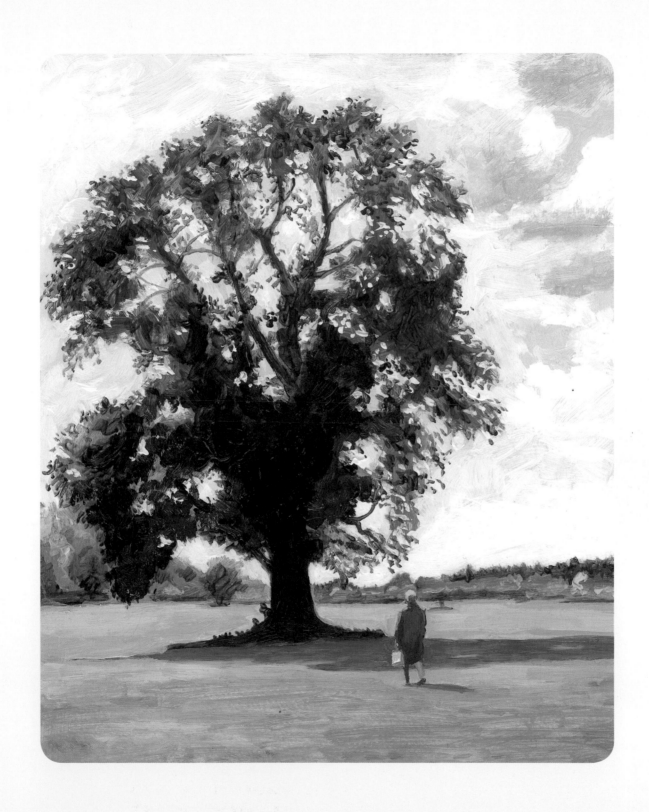

VEGETATION

As landscapes are largely covered by some form of vegetation, the first stage when tackling this genre of painting is to try your hand at depicting plants. A whole landscape can be a daunting prospect, but if you can paint a single plant well it's just a matter of translating the knowledge and skill you have gained into showing vegetation on a larger scale.

I have chosen a couple of pot plants, one with large leaves and one where you can see the shape of the whole plant. As you learn how to show the way in which the leaves grow off the main stems you'll be discovering how to deal with trees when you start painting a larger part of the landscape.

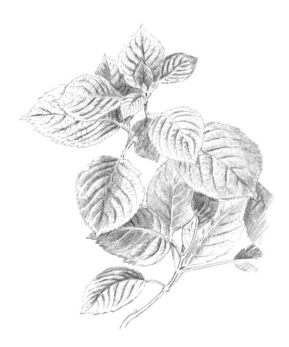

Stage 1

First, make a careful drawing of the group of leaves, going into some detail. If you have a good drawing to start with you'll be able to paint the final result with more accuracy; leaves very often change angle and either droop or perk up at different times of the day, and if you're painting directly from life over a period of hours you may find these subtle differences confusing.

Stage 2

Prepare the canvas or board with a coloured ground – I have used Burnt Sienna – then transfer the drawing on to it by marking out a line drawing in paint. There's no need to draw every detail this time – just the outline of the leaves and the position of the stems.

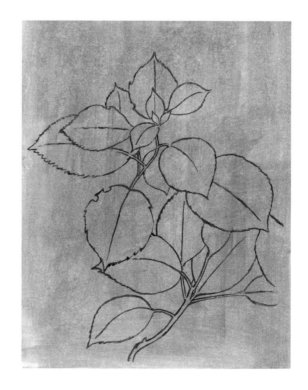

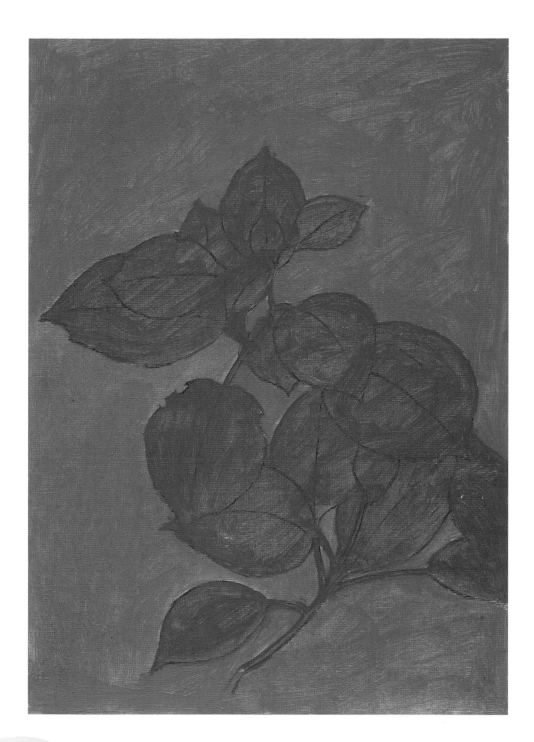

Stage 3

Next comes the laying on of the main colour blocks. In my case the plant was standing on the lawn outside my studio so the background colour was also green, although a cooler and lighter green than the main colour of the leaves. If you think that the lack of colour contrast will make your painting harder to do successfully, just choose a more contrasting background.

When I had put in the grass colour, I coloured all the leaves with one darker tone of green. The background is mainly Permanent Green Light with a little Naples Yellow, and the leaves are Permanent Sap Green. I have painted both colours quite thinly so that the underdrawing is still evident.

Stage 4

The next stage is to paint in the dark and light tones on the leaves that help to define their shape and texture, using the Sap Green in its strongest tone for the darker areas and adding some Cadmium Yellow Light to it for the lighter ones. This is also the time to define the veins and edges of the leaves and to show how the stalks are also variable in tone.

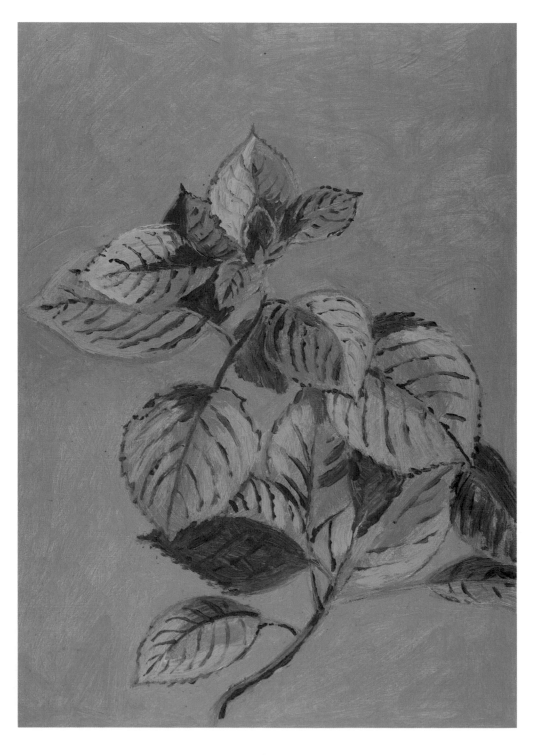

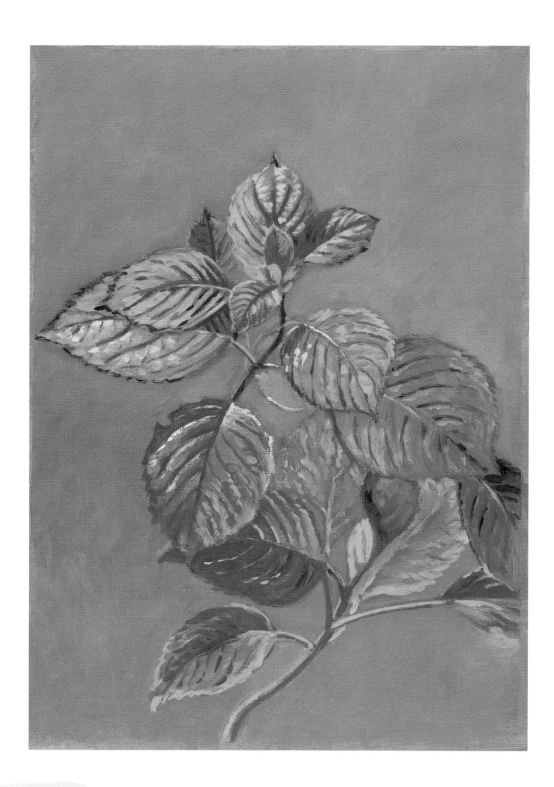

Stage 5

Now we come to the final stage where you can refine the shapes and make the whole picture more natural. In some places there is a brown edge to the leaves, which a little Burnt Sienna is appropriate for, and then there are some areas where the light catches the leaves more strongly, shown with Sap Green mixed with Titanium White. Finally, I went over the background colour with a thin layer, starting at the top with some blue-green and finishing at the bottom with some yellow-green.

85

SHOWING GROWTH

The second plant was again posed on the lawn and so my background is treated in a similar way to the previous painting. This time, though, the presence of the pot added extra colour to the subject.

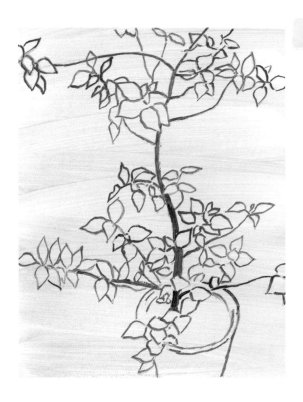

Stage 1

For the preparation of this canvas I used Terre Verte green, which is a cool dark green, but without too much solidity; it is the colour of most Renaissance underpaintings. After this, the first thing was to draw in the shape of the plant, showing how the stem and branches grow out and up. Then to put in the outline leaf shapes, which in this case are much smaller than the previous plant.

Stage 2

Blocking in the main colours now, I had also to consider the pot that the small tree is growing in, which is Burnt Sienna mixed with some Naples Yellow. I used the same colour for the stem and branches as well. The earth in the pot was covered with bits of brown debris from the tree, so I applied the same colour mix with the addition of some Burnt Umber to darken and dull it down. The leaves are Permanent Sap Green, mixed with French Ultramarine to sharpen it. To block in the background colour, I used a mix similar to the one in the previous painting.

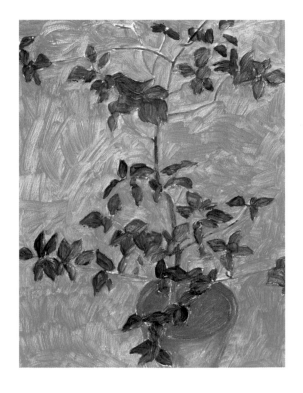

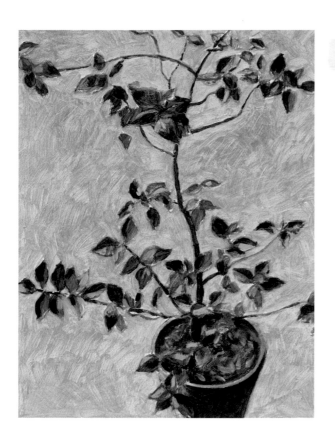

Stage 3

Next came the stage of defining the leaves and branches, which I did with a lighter and darker version of the green that I had used for blocking in the main colour. The pot also needed to be defined with dark shadows and light edges along the top. I textured the contents of the pot in the same way, adding blue for darker tones and white for lighter. At this stage I felt that the background looked too strong, so I washed over it a thin layer of the original green mixed with white to push back the colour.

Stage 4

The final stage is where the refinements of shape and colour take place in a painting. First I textured the background to give the effect of grass, putting down strokes of brighter green, duller green and brownish tones. The only new colour I introduced here was Permanent Green Light, which is a very strong green. I then worked over the leaf shapes, lightening some, darkening others and giving yellow edges here and there mixed from Cadmium Yellow Light plus some white or Naples Yellow. The darker greens were created with additions of Viridian or French Ultramarine, depending on how they looked from where I was sitting. The pot needed a bit more work to lighten or darken areas, though no new colours were brought in.

Notice how the texture of the grass is more evident closer to the lower edge of the picture and less obvious at the top – this represents what the human eye would actually see.

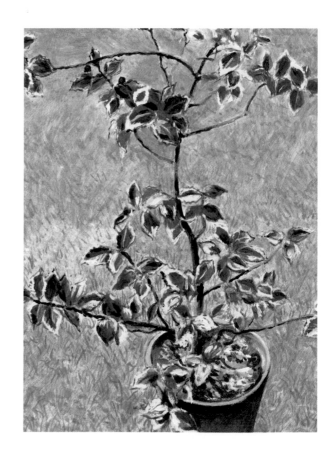

GARDEN SCENE

The environment of your own garden may give you enough space to paint just a small area of landscape. While you may feel this is rather limited, it is in fact better to try a constricted space before you go for something more open.

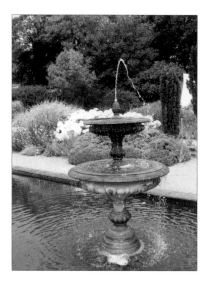

If you haven't got a garden of your own, any park in your neighbourhood will do. I chose to go out to a garden belonging to a stately home, picking a spot from where I could make an interesting fountain my central point. I didn't particularly choose the background, just allowing the general area of plants and flowers to be seen behind the main form. I've included a photograph of the scene to show my approach.

Stage 1

Drawing the outline on prepared canvas as usual was my first task. The main aim was to get the fountain looking stable and well formed and then just block in the main areas of shrubs behind.

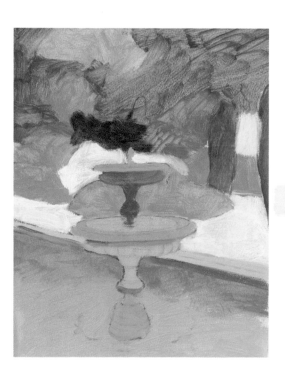

Stage 2

Next I blocked in the main local colours, which were largely variations on green. I used Permanent Sap Green, Viridian, Naples Yellow, Cadmium Yellow Light and a touch of French Ultramarine, with Titanium White to reduce some of the colours.

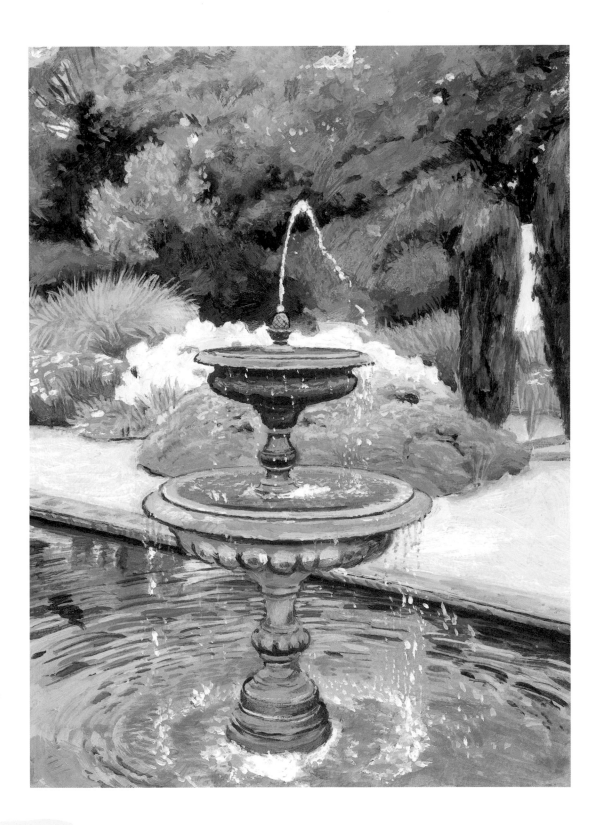

Stage 3

To finish off the picture I did a lot of careful defining with darker tones of the colours I'd already used, adding a little Burnt Umber and Burnt Sienna to bring out the colours more accurately.

89

PAINTING A TREE

The next step on your way to painting a whole landscape is to try a big tree in order to familiarize yourself with the size and grandeur of larger areas of vegetation. I left the garden where I was painting the fountain and walked into the adjoining parkland, where there were a lot of large trees. I photographed the scene, including a human figure walking across the grass, to give you an accurate idea of proportions.

Stage 1

First comes the drawing on a prepared surface as before, blocking in the main outline shape of the tree and the environs immediately behind it. Block in the large shadow stretching below it, and include the main branches that you can see through the gaps in the foliage. Don't try to describe the bits where the gaps are partly covered in thin layers of leaves – just show them as gaps wherever you can see the branches.

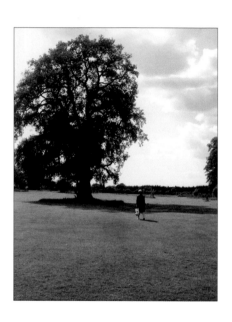

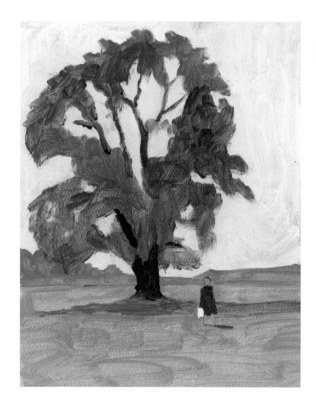

Stage 2

Next block in the sky colour, which as you can see was rather cloudy, though bright. I used a mix of Titanium White with a little French Ultramarine, keeping the whole sky quite light in contrast to the tree. The tree was blocked in with mainly Permanent Sap Green and Burnt Umber and for the rest of the scene I laid down the same green, reduced a little with either Naples Yellow or Titanium White, or a mix of both. I then added a little Cadmium Yellow to brighten up the green in the foreground.

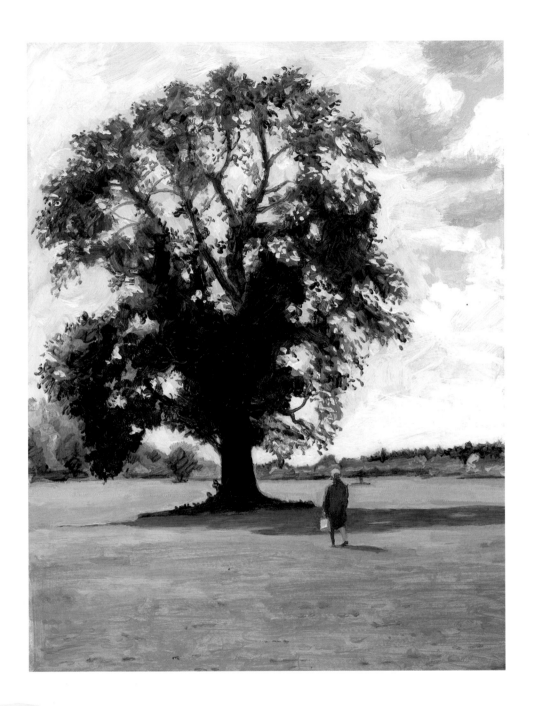

Stage 3

To finish the sky, work over it to give the effect of clouds, either darkening it with grey (Burnt Umber and French Ultramarine mixed with Titanium White) or adding a little Cerulean Blue and Dioxazine Purple mixed with white for areas of sky showing through the clouds. Then turn your attention to the tree, defining it with various versions of green, blue and brown. You could even put a little Dioxazine Purple in with the greens to darken them in an interesting way.

The background scene needs some yellow of different kinds to lighten up the grass where the sun is shining on it, as do the treetops in the background, which look much lighter than the tree. You don't have to draw every leaf – a general effect of uneven leaf masses is the way to tackle it, but be a bit more deliberate with the outer edges of the tree.

THE BROADER LANDSCAPE

Now we're going to look at a landscape that has all the elements required to make an attractive painting. I have used the popular device of a narrow lane disappearing into the middle ground around a bend in the road, which is an easy way of indicating depth in a picture and tempts the viewer to imagine walking into the landscape. Fringing the lane are yew hedges that have been carefully cut into formal shapes, while behind them are trees with more natural growth, making a pleasing contrast. The weather is quite overcast, so there is no bright sunlight and the shadows are softer.

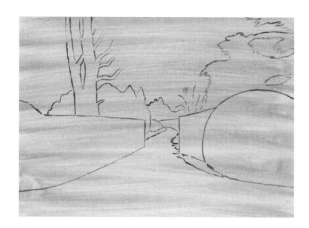

Stage 1

Starting with the drawing on a prepared canvas in Burnt Sienna, as is my usual practice, I put in all the main lines of the composition, without worrying too much about any detail. The main thing here is to get the proportions right and the limits of your picture decided. I decided that the formally cut hedges would be the largest part of the foreground, with the path coming towards the centre and filling the lower part of the picture.

Stage 2

Next I put in the main areas of local colour. The sky was grey, so I mixed up some French Ultramarine, Burnt Umber and Titanium White to get a medium light grey for it. I used a darker version of the same colour for the path, then blocked in the hedges with Permanent Sap Green mixed with a little white and a touch of Naples Yellow. For the lighter trees in the background I applied the same mix of colour, but with more white and yellow. Then, for the brighter greens of the other trees and the grass, I used Viridian with sometimes a touch of Naples Yellow and in other areas some Burnt Sienna. I darkened the trunks of the trees and some of the deeper tones on the hedges with Burnt Umber and Burnt Sienna and put in a bit more drawing on the tree branches.

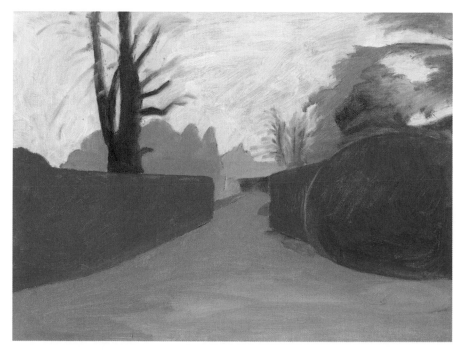

92

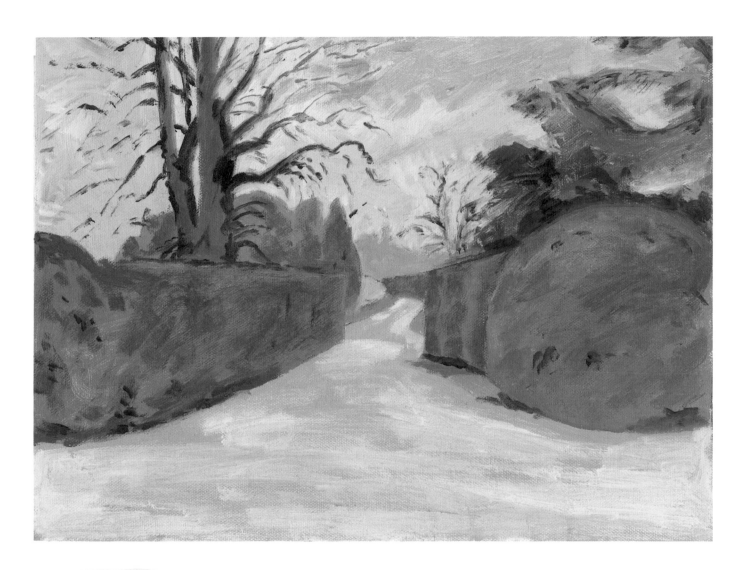

Stage 3

To show many of the darker parts of the picture, including the branches, I began to use some Olive Green. Some lighter tones were needed on the hedges and tree trunks, which I put in with Olive Green mixed with a bit of brownish-yellow to soften it as well as some lighter versions of the Sap Green made with the addition of Naples Yellow or Cadmium Yellow Light and some white. On the road surface I scumbled a much lighter version of the grey used before, leaving darker bits here and there so that the texture of the road shows. Lighter and darker tones in the sky gave the effect of clouds that might presage rain. A few dark patches on the hedges to suggest holes in the formal surface could also be put in now, especially along the lower edge of the hedge.

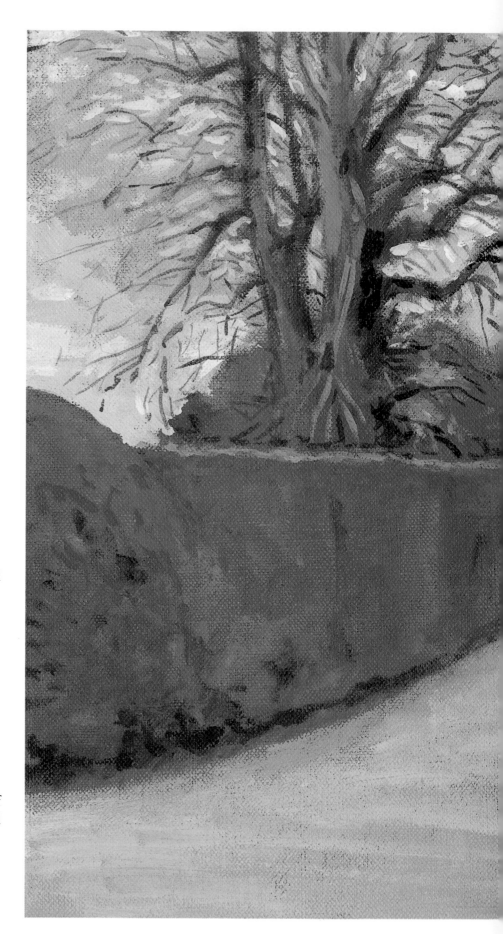

Stage 4

This is a very important part of
a landscape painting, because
it is now you need to describe
everything that will convince the
viewer that they are looking at
a real landscape. The sky took
up a lot of my attention, since I
wanted to make sure it looked
light enough for the trees to
be silhouetted against it. The
branches of the trees were quite
carefully traced in with both dark
tones and some lighter ones. In
the foreground the hedges needed
many more little touches of
colour in different tones to give
them the right feeling of being
both closer and richer in tone
and texture.

At this stage keep stepping
back from your work so that
you get a good idea of the whole
effect, otherwise you will get too
tied up with details that are not
necessarily working well. When
the overall effect gives the sense of
depth and a feeling that you could
actually touch the leafy parts of
the nearest plants, stop – it's all
too easy to spoil a painting by
continuing to add unnecessary
details that spoil its freshness.

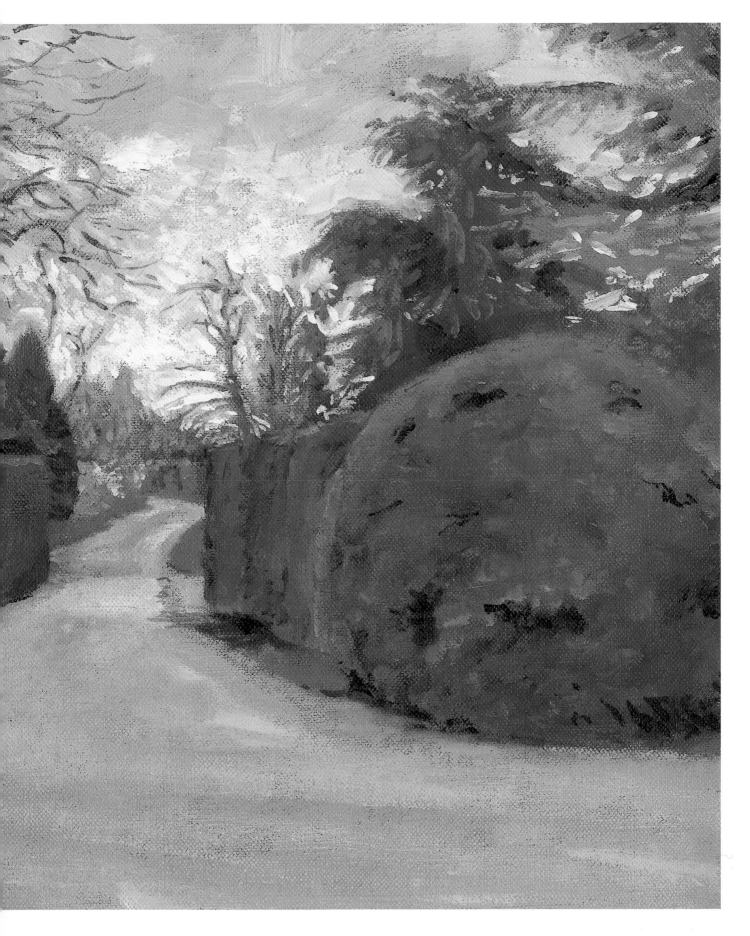

OPEN LANDSCAPE

Here we look at a landscape that is much larger in scope than the previous one. There is no special part that your eye is directed to, as there was in the lane, and the effect is one of open space, with the impression of much more stretching outside the field of vision.

Stage 1

On a prepared canvas, I drew the main parts of the composition in Burnt Sienna. This is really a series of horizontal shapes across the width of the picture, showing the sky, the distant line of trees, the trees and bushes in the middle ground and an expanse of pastureland in the foreground. To provide the viewer with an understanding of the distance of each part, the wire and fence posts in the immediate foreground give a lower frame to the space.

Stage 2

The next task was to block in the main colours of the area to be painted. The sky is a lightish blue, the distant trees are a light soft green and as the eye comes forward the pasture and trees are painted richer colours. The posts of the wire fence in the front of the picture are partly lit and partly in shadow, so they stand out against the grassland. The colours I've used are Cerulean Blue, Titanium White, Permanent Sap Green, Permanent Green Light, and a little Naples Yellow. See if you can work out which I've used where.

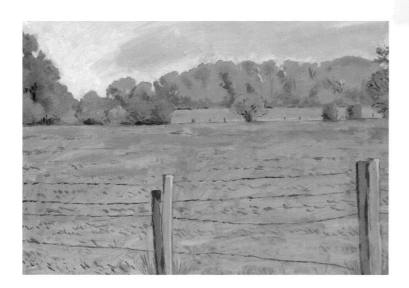

Stage 3

So that the whole composition would appear to recede into the distance, I needed to modulate the tones and textures of the colours of the trees and pasture. All the shadows and definition of the background needed to be muted in colour and close in tone while towards the foreground the colours could become stronger and richer, with lots of warm colours at the front. The marks made by the brush could be sharper and deeper in tone, with more contrast and texture.

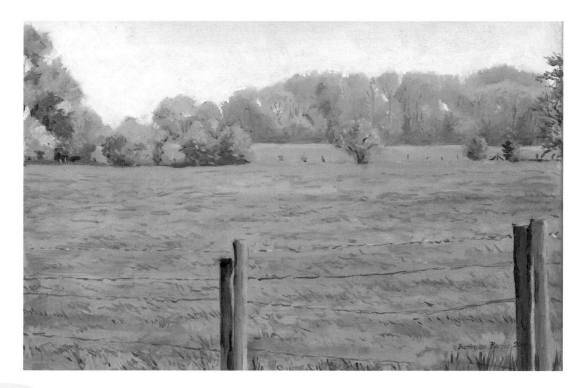

Stage 4

This final part of the painting is where the feeling of the space you are trying to show becomes convincing to the viewer. A certain amount of work on the sky gives the effect of haze and mist, and the far trees that define the furthest distance are carefully modelled in closely similar colours and tones. Nothing in the background should jump out at you – it should all look very soft and hazy. The next line of trees can be a bit more definite with slightly stronger colours and contrasts, but not too much, because they are still meant to be about 100m (109yd) from the viewer.

As the eye comes across the width and depth of the grass, the marks can get stronger and more varied, until right up to the fence, which should be the most sharply defined object in the composition. Here I've put in light and dark marks to suggest the barbed wire with which the fence was made.

HILLSIDE LANDSCAPE

This is an attractive hilly landscape in the north of Italy, near to the Alps. It is both open and wooded, with large curves of hillside to divide the composition.

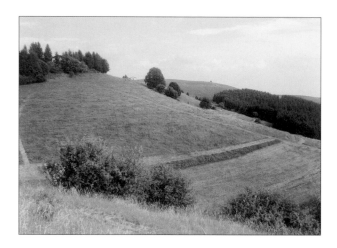 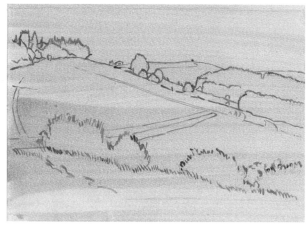

Stage 1

I started as before with an outline of the main shapes of the view, keeping the marks simple and broad. Although there are more elements in this scene than in the previous one, there's no need to start putting in detail.

Stage 2

The second stage was to block in the main colours, taking care to show how much lighter the sky is than the rolling landscape, with its clumps of dark vegetation. The nearest parts of the composition are warmer in colour than the further parts. The colours I used were Cerulean Blue, Titanium White, Permanent Sap Green, Burnt Sienna, Naples Yellow and Permanent Green Light.

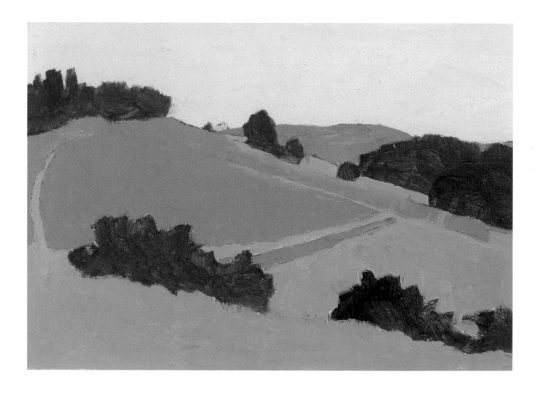

Stage 3

Next I put in the clouds and defined the vegetation, breaking up the grassland with marks in colours that start to give some texture to the surface areas. Note how the light falls on the trees and bushes and remember that the foreground marks can be much bolder than those on the distant landscape. When this part looks effective all over your own composition you can move on to the fourth stage and finalize the colours and tones.

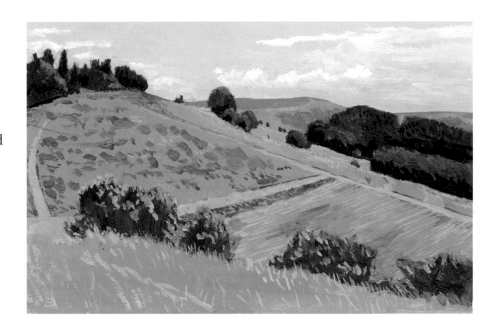

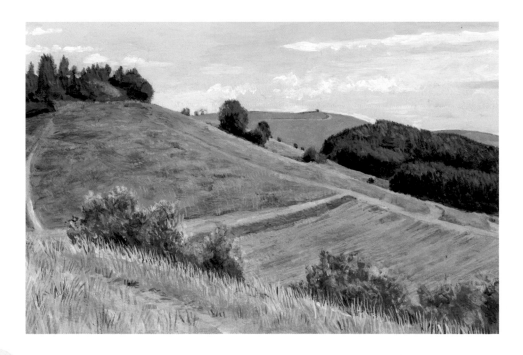

Stage 4

The last stage is one of carefully observing the way the marks that you make can indicate the texture of the sky, trees, bushes and pastureland. After building up the marks slowly you can often smudge the surface a bit with a brush or your fingers to get the right effect for the landscape. Don't get too obsessive about the perfection of the marks that you have painted in – experiment instead with smudging and laying glazes or washes over the finished surface and you may find exactly the quality that you are looking for.

After I thought I had finished I noticed that the foreground should look much warmer than I had painted it, so I loosely washed a tone of Burnt Sienna and Naples Yellow over the whole of the foreground areas and then smudged it lightly with my thumb. It now seemed just right.

MOUNTAIN LANDSCAPE

The main difference between a mountain landscape and hilly or lowland areas is that, seen from a distance, mountains look rather bluer than most other backgrounds. This is partly because of the distance that you are seeing them from, and therefore the amount of atmospheric haze that intervenes, and partly because mist or clouds tend to gather around them.

Stage 1

As in our previous paintings the main shapes are drawn with a brush on a prepared surface, but this time, because it is to be a cool-coloured picture, I have used a grey-green tone mixed from Viridian, Permanent Sap Green and Titanium White and drawn the outlines in Burnt Umber.

Stage 2

In order to get the right darkness of the overclouded sky I painted it in a blue-grey colour of French Ultramarine, Burnt Umber and Titanium White. Then I put in the shape of the most mountainous area with Viridian, French Ultramarine and Titanium White, making it just a little darker in tone then the sky. For the next layer of hills I used a greeny grey with a bit of yellow in it, mixed from the Sap Green, French Ultramarine and Naples Yellow, in exactly the same tone as the mountains. Then the foreground was painted with layers of Sap Green, Sap Green

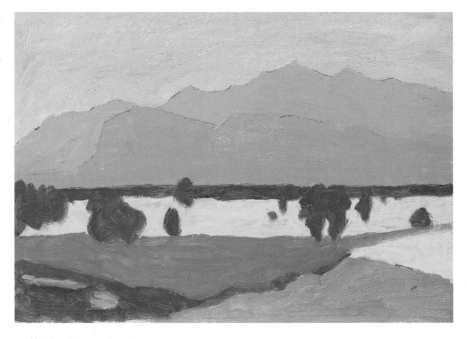

mixed with Cadmium Yellow Light and a touch of white, Burnt Sienna and Sap Green and Burnt Sienna and Naples Yellow. All the trees were painted in Sap Green.

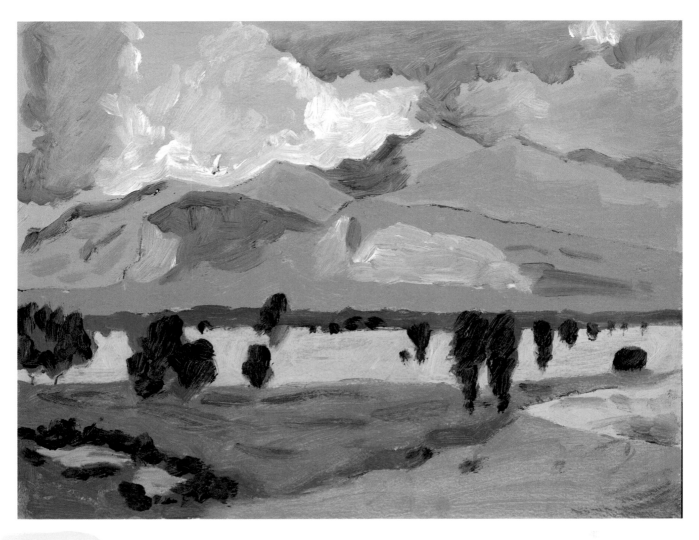

Stage 3

In the next stage I had to mix up colours that I had already used but in slightly different combinations to make them bluer, browner or paler. The clouds needed definition and the different peaks of the mountain range had to be indicated to increase the effect of their bulk. In the foreground, the trees needed differentiating so that they appeared to be either closer or further away. Some more detail was also required in the foreground to increase the texture.

Stage 4

(on next page) In the final stage all the details could be put in, with softening of the cloudscape and detailing of the rocky parts of the mountains. Then I worked up the foreground to make it look closer and more definite, while the mid ground of the trees and plain could be carefully transformed with subtle details to give the effect of land stretching back from our view.

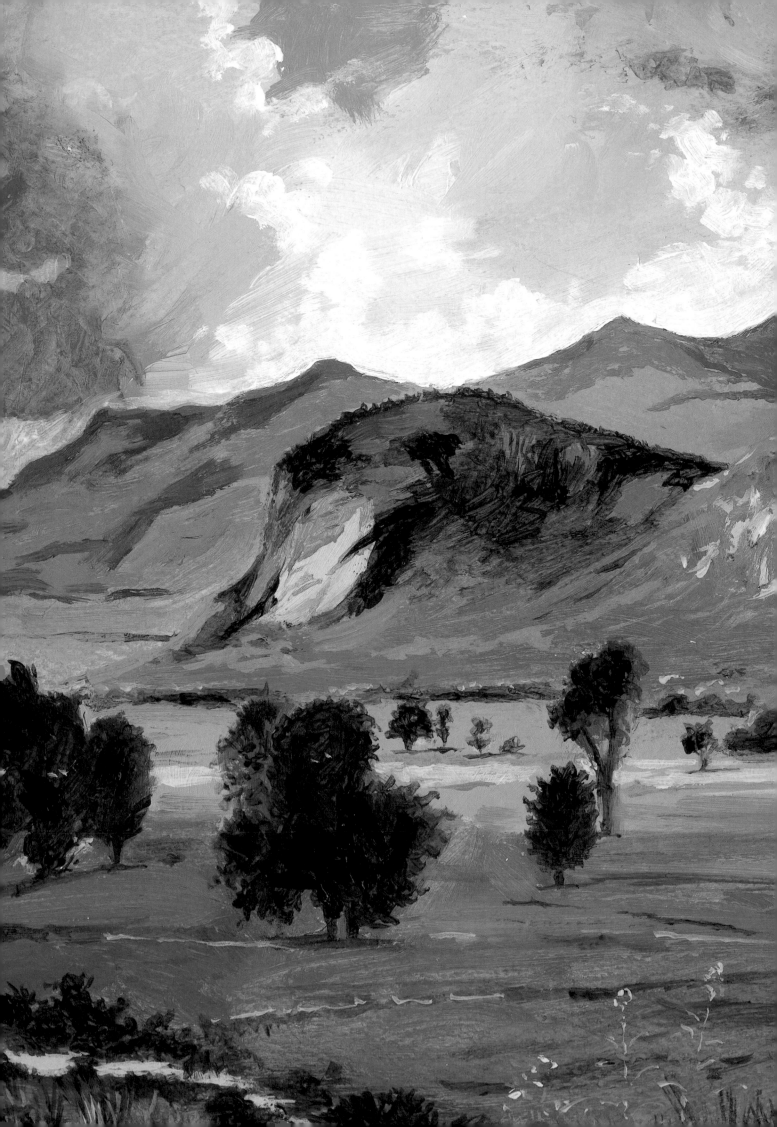

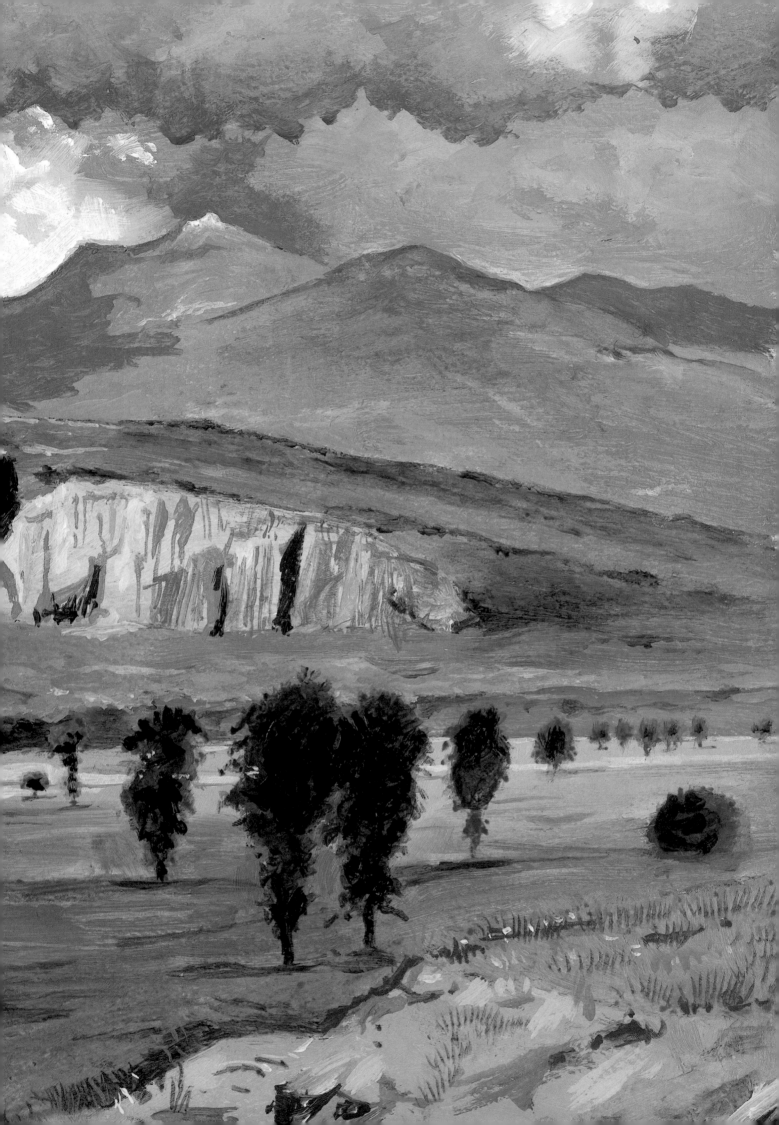

SKIES: PRACTICE

In any landscape the sky always has a big part to play, even if only as background. Many landscape painters have had great fun working up their cloudscapes to add some emotional content to what might otherwise be rather tame landscapes.

Storm Clouds

The most obvious use of the sky is in storm clouds, making any landscape beneath look more dramatic against the dark sky.

Heavy Cumulus Clouds

Large, rolling cumulus clouds can give a very active effect, as they appear to move across the upper part of your picture.

Cirrocumulus Clouds

A summer sky with its blue vault touched with a few cirrus-type clouds is a good way to bring light and peace to a scene.

Small Altocumulus Clouds

On a day of sunlight and warmth, distant haze and altocumulus clouds help to increase the feeling of delight in the day.

Cirrus Clouds

A sunny day may have streams of cirrus clouds across the sky with a warm-coloured haze in the far distance to give the feel of summer.

Evening Sky

When the sun starts to go down and the clouds are bright with a warm glow, the scene can look very peaceful.

A SEASCAPE

Large expanses of water are very interesting to paint and the sea is a particularly beautiful subject. In terms of drawing there's not necessarily a great deal of structure to show; the main elements are the water, the horizon and the sky, so you have to decide where you are going to place your horizon and how much of the shore and distant landscape to include. In the example here the horizon line is about two-thirds up from the lower edge and the view is along the beach to a breakwater, with a distant stretch of land visible beyond a bay.

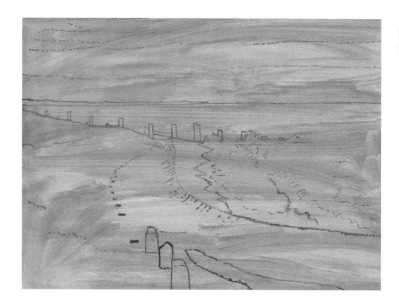

Stage 1

The drawing on prepared canvas is to show the horizon, the far stretch of coast, the large expanse of the pebble beach in the foreground and the medium-sized area of sea between the horizon and the lower right-hand corner.

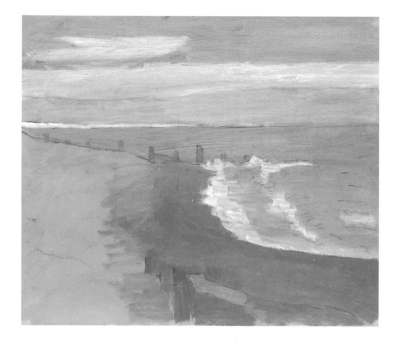

Stage 2

First I blocked in the sky, using a mixture of Cerulean Blue and Titanium White and showing the stretch of cloud across the sky in white. The far coastline was put in using white as well and the main area of the sea in a mix of Cerulean Blue and Viridian plus a touch of Naples Yellow. The surf and foam were painted in white while the beach, which is made up of many small stones, has an overall colour made from a mixture of Naples Yellow and Burnt Sienna – the area close to the surf has more of the latter. Burnt Sienna mixed with Viridian made the right initial colour for the wooden breakwater posts.

Stage 3

Next comes the defining part of the painting, where the areas of colour were built up to represent the different variations in the sky, sea and beach. The sky needed refining to get the effect of thin altostratus clouds streaked across the light blue summer sky, while the distant coastline gained a faint set of marks to give it a little more solidity than the sky and sea.

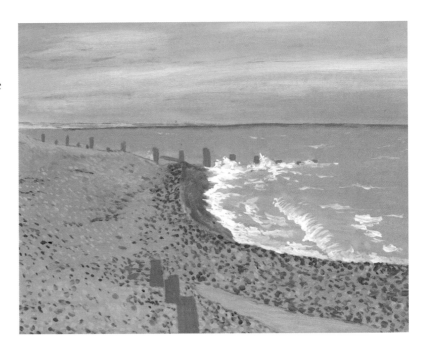

The sea was darkened with some French Ultramarine towards the horizon line, not too insistently applied. I defined the foam and surf more carefully to show the wave breaking on the beach, then built up small pebble-like marks covering the beach in browns and greys, with the largest marks in the foreground and the smallest, faintest marks further back. I darkened the wooden posts of the breakwater and defined the ridge of pebbles along and around the beach nearest to the surf. Then the small stretch of water caught along the edge of the pebble ridge needed to look rather greener.

Stage 4

The sky required refining in order to gain a summery look, with some French Ultramarine and Dioxazine Purple mixed with white to give a distant, hazy look to the lower part below the main cloud areas. Some flicks of paint faintly applied along the distant coast gave the effect of buildings or other objects. I then built up the sea in small marks to show darker strips and white wave crests in the distance and defined the breaking wave in the foreground in more detail. The beach needed even more building up of small marks to produce the effect of pebbles and the breakwater wooden posts gained more detail on them, especially the nearer ones. Your longest task here

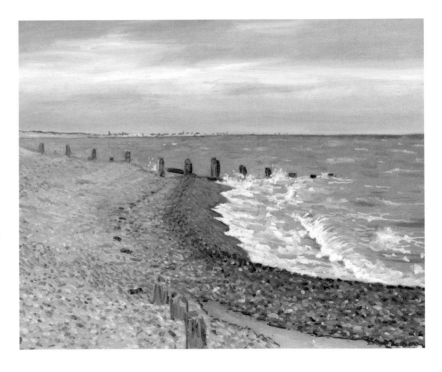

is the beach, making the marks repetitively until it starts to look like the beach that you can see. You can afford to smudge tones over the further areas so that they recede into the distance more obviously.

LANDSCAPE WITH BUILDINGS

Urban landscapes present a very different task to rural ones, and to ease the passage from one to the other it's a good idea to try a landscape with a building in it. Here I was in front of an old church in a country estate, so the contrast between this and a landscape without buildings was minor.

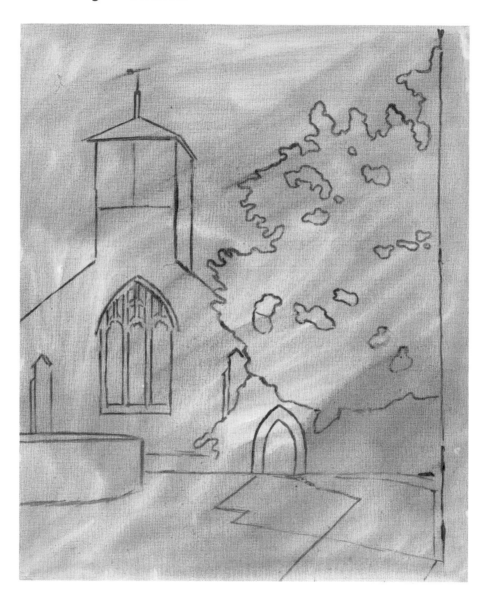

Stage 1

Once again the outline drawing gives you your composition, and this time I've gone for a upright format rather than the horizontal one that most landscapes are done in. I've carefully cut off the edge of the church on one side and framed it with the tree on the other. This puts it just far enough away from me to see most of it without getting caught up in defining the depth of the whole building. Here it is almost like a stage set, half church and tower and half tree.

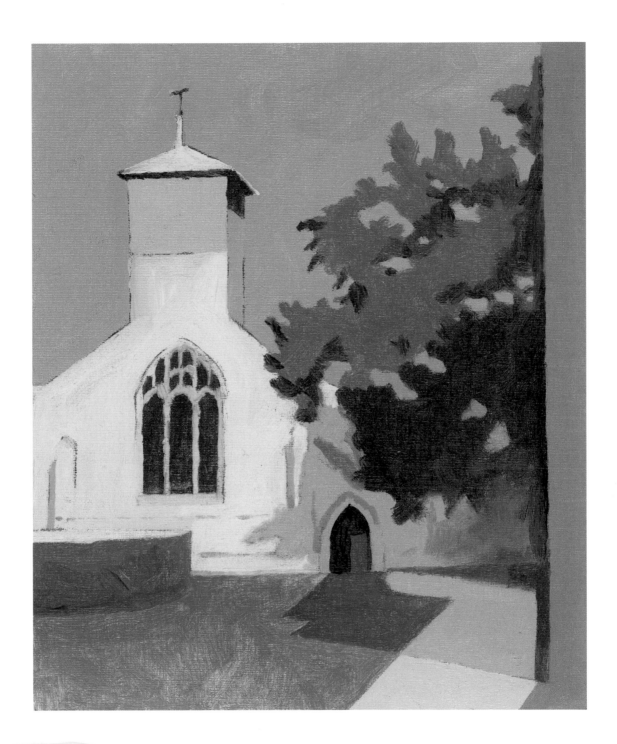

Stage 2

Blocking in the local colour was not difficult because the church was very light in tone, the tree was quite a bit darker and the grass and bush were a richer colour. On the right-hand edge is the corner of the grand house that the church belongs to, but I have just included the corner as a bracketing device. Because this was in the summer, the sky was a bright blue which I made with Cerulean Blue and Titanium White. Against this the church was mainly painted in Naples Yellow and white, with a touch of French Ultramarine to cool it down. The greens are all variations on Permanent Sap Green with mixtures of white, Naples Yellow or Viridian. The deepest shadows are made with the addition of French Ultramarine.

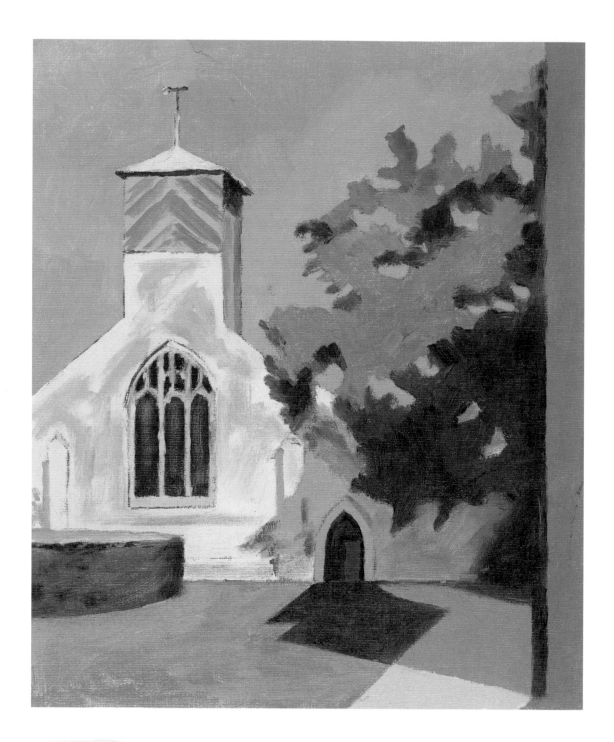

Stage 3

The next stage was a bit difficult, because it's always at this point that the painter can get carried away with details, when what they need to do is to keep the whole picture in mind. I had to be careful how much to put in before the finishing stage, so it was a process of adding bits of colour and tone to get more accurate renderings of the real look of the place. This was mostly done on the church, tree, grass and bush. The shadows on the church had to be made more complete and the depth of the shadows under the tree needed to be worked on too.

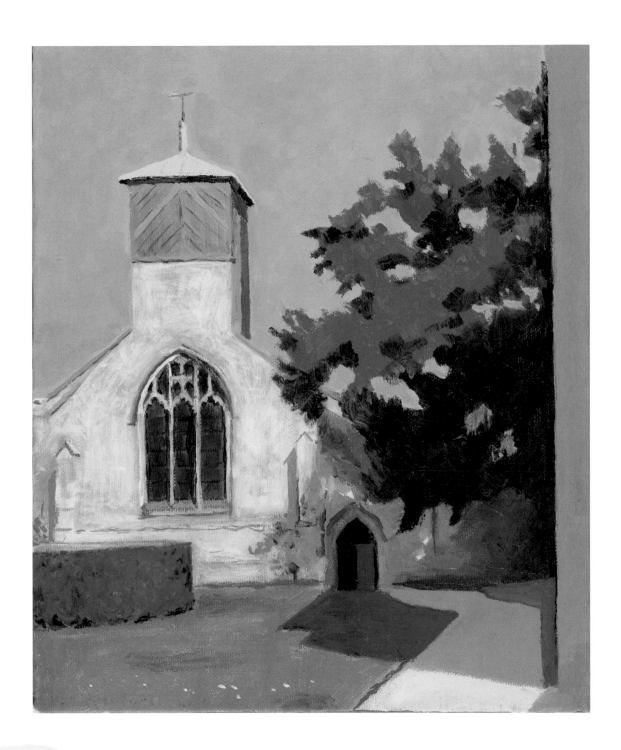

Stage 4

Now, with very little actual painting going on, came the final touches that would make the picture successful or not. Some work on the nearest parts of the ground needed careful attention, and the little dots of daisies on the lawn helped to bring the foreground forward. The bush required thought to get the mix of colour and texture right and the shadows on the church needed to be made more subtle. The texture of the wooden boards on the church tower and the stone tracery around the windows took some time to get right, while the tree needed a bit of colour change in parts. This all took quite some time, even though most of it was not in fact taken up with laying on paint. However, if you carry out this step rigorously enough your own final picture will be much more effective.

URBAN LANDSCAPE

The painting of an urban landscape is a little more difficult in practical terms because the space available to set up an easel and stand painting in the street is usually limited. Passersby are mainly very courteous and tend to be appreciative of the efforts of the artist, but ideally you should find a place where you won't cause any obstruction.

The next problem is to decide how much of the crowded scene you want to include. A view along the side of a street where you can see the far end is usually good because there is a natural limit to your space, so that's what I've chosen to depict. The light in this London street is interesting, because the buildings behind me are casting a shadow across the lower half of the street.

Stage 1

The first thing is to make sure that your perspective will work in the picture, so a bit of careful drawing and measuring will help here. As you can see from the adjoining perspective diagram, the vanishing point of the main lines of the perspective is not even on the picture, so a certain amount of guesswork is useful here. It won't matter if your perspective isn't entirely accurate as long as the feel of the space is captured well.

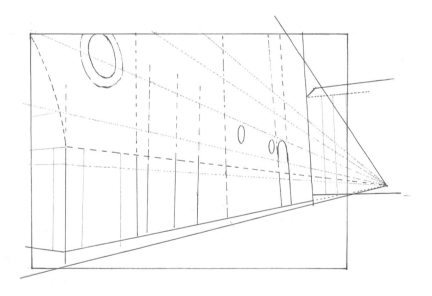

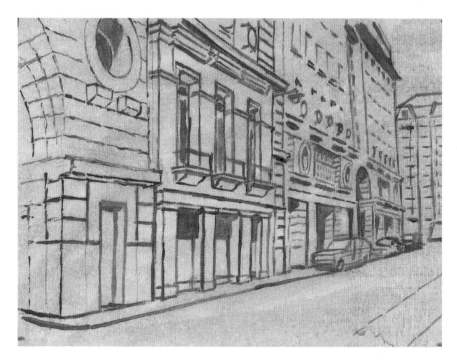

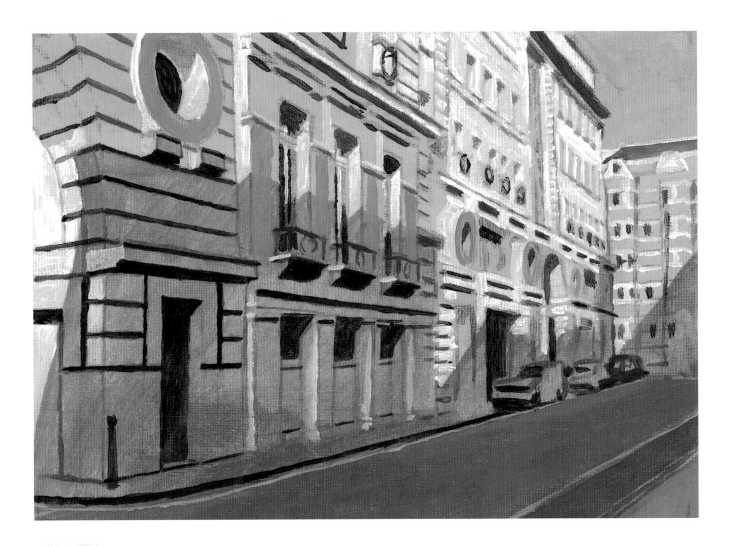

Stage 2

In this painting the buildings are partially in strong sunlight and partially obscured by shadows cast by the buildings on the opposite side of the road. This means that the lower half of the buildings looks much darker in tone and colour than the rest of the picture, so when you start blocking in, define the edge of the darker shadow as well as all the obvious changes of colour as I have done. All of the lower half of the scene will seem much darker than the rest, but don't put it in too heavily at first, because you will find it needs careful building up of all the changing surfaces within the darker shadow.

Stage 3

When all the main colour values are present, you now come to the part that requires much slow, careful defining of the detailed shapes, and the various subtle colour ranges within the overall context. The nearer parts of the buildings will be stronger in colour and more definite in the edges of the hard surfaces. Build up the darker parts gradually and try to get the contrast between the light areas and the very darkest parts. The further the buildings are from the viewing position the less sharply defined the details need to be.

114

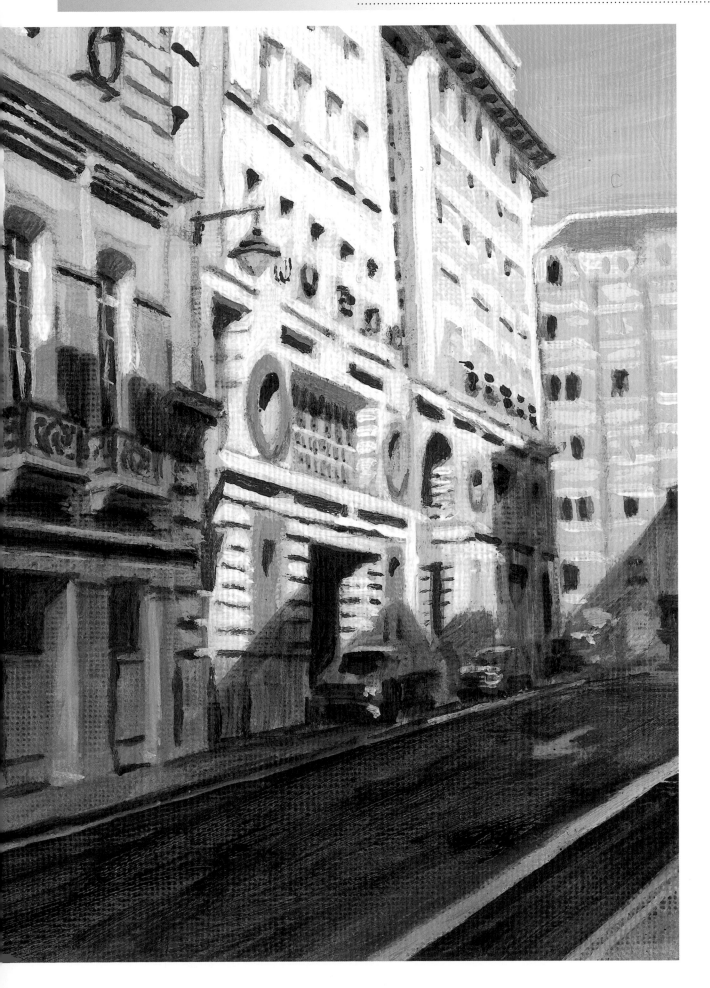

CHAPTER 5

PORTRAITS AND FIGURES

This is where you get to grips with the rather more difficult task of painting people. Since your models will be able to stay still for only a short while it's an area of painting where photography can be a real asset to record their poses, and even more so if you want to show figures in motion.

Figure compositions are usually more complex than individual portraits, so it's probably best to start with some portraiture before tackling figures in quantity. Because the human figure is so familiar to all of us, it's essential to paint people with competency in order to convince the viewer, and studying one person in depth will help to develop your skills in this respect.

So, in this section I have combined portrait and figure painting and aimed to guide you through the process of looking very carefully at people as a subject for a painting. Of all exercises, this is probably the most interesting for the majority of artists because of the engagement with other people.

PORTRAITS

Most learning artists, having got to the point of painting the world around them, become keen to try a portrait. The most obvious aspect of this is painting the face, but as you will see there are a lot of other points to consider. A portrait may be a head, a half figure, or the complete full-length figure, all calling for various kinds of detailed attention from the artist.

Choosing A View

The easiest way to start is with a close-up of just the head of someone who is prepared to sit for you for a while. If the painting is indoors, as it's most likely to be, make sure that the lighting is even enough for you to be able to see all the features clearly and also in a position that you can come back to if you don't finish the portrait in one sitting. Most good portraits take at least two or three sittings, so to start with, choose someone who you know will be patient. First you will need to decide how you want to be able to see your sitter – full face, three-quarter face or in profile.

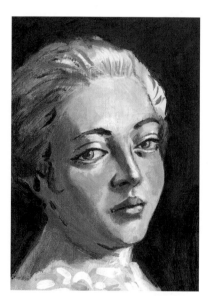

Three-Quarter View

The most classic view is three-quarter face, because it shows both the eyes and the shape of the nose. If you paint your sitter full face the nose is less obvious, while in profile you can see only one eye.

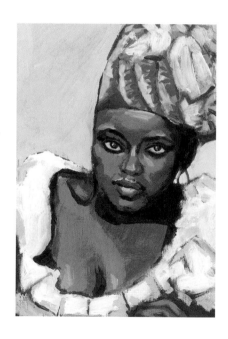

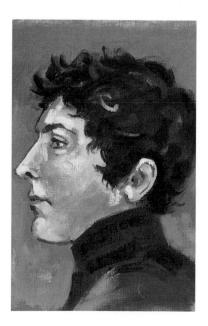

Profile

It's said that in Ancient Greece a painter drew around the shadow of his lover's profile and that was the first portrait ever made. Whether this is true or not, many of the earliest portraits of the Renaissance were profile views, it being the easiest way to show someone's face clearly as others saw them. Of course the individuals painted didn't necessarily recognize their own face, as few would have seen their profile before.

Head And Shoulders

The next example is full face but with the addition of the shoulders and a hint of the hands. This takes us closer to how we recognize people, because we are rarely close up to someone's face. It's a clearer view of how you would see the head in relation to the body, with a suggestion of the sitter's position. Most modern portraits include at least this much of the figure, especially as you can also show clothes that the sitter likes to wear.

Half Figure

The next portrait example is of a half figure. The addition of a pet or some object that the sitter wants to hold can add an extra dimension of individuality to the portrait. Here we have a young woman holding her kitten up near her shoulder while she leans against a doorway with some strong daylight behind her. This can add to the drama of the picture, but you have to look very carefully at the tonal range of the whole composition to make it work well.

Often a pet will not stay still for long, so once you have got the pose, photograph the pet so that when it wants to leave you have some reference from which to complete the painting.

Full Figure

The full figure portrait is often used because the sitter has more opportunity to show the image that they want to project. In our example the man is seated, holding an antique book of some sort on his lap and leaning on an old wooden figure that is merely suggested. He is smartly dressed in a formal suit with a white shirt and striped tie to give a feeling of importance to an otherwise fairly casual seated pose. He looks as though he knows his own worth and is fairly happy with himself.

Standing Figure

The full figure standing used to be the most formal of all portrait poses, often with the addition of meaningful objects in the foreground and glimpsed scenes in the background. While this is a bit more relaxed, it nevertheless shows a young woman in an elegant long dress with her hair carefully arranged, and with a background so uncluttered that the very drama of the dark doorway and the plain walls and floor give some formality to the pose. Again this seems to show the self-confidence of the sitter, requiring no adornment to add to her presence. Very simple use of local colour helps to give this some power.

A YOUNG MAN

When you are painting a portrait, the most sensible way to start is to do a little measuring of the head, especially if you are a beginner. You may feel it's a bit pedantic and delays you from the enjoyable painting process, but you'll find it really helps you to achieve a good likeness.

Stage 1

With a good-sized ruler or straight edge, measure the width and length of the head from your viewpoint. Once you have these measurements marked on your prepared canvas or board, you can then note the position of the eyes, the end of the nose and the centre line of the mouth in relation to the top of the head and the chin.

It's also useful to ascertain where the centre of the head appears to be from your viewpoint – in the example shown here it is about where the nearest eye is. With a few checks like this you should be able to portray the shape of the head accurately.

Some artists start by marking in the eyes, followed by the nose and mouth, and then paint out from there to find the right shape for the face and head, but this can be difficult if you have never painted a portrait before.

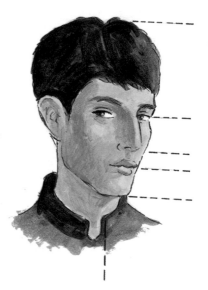

Stage 2

Next you can begin to trace an outline of the head and features on to your surface, using a small pointed brush to draw it in a darker tone than the ground. Keep the shape fairly simple, without worrying too much about any details at this stage – you need only get the main shapes and positions right.

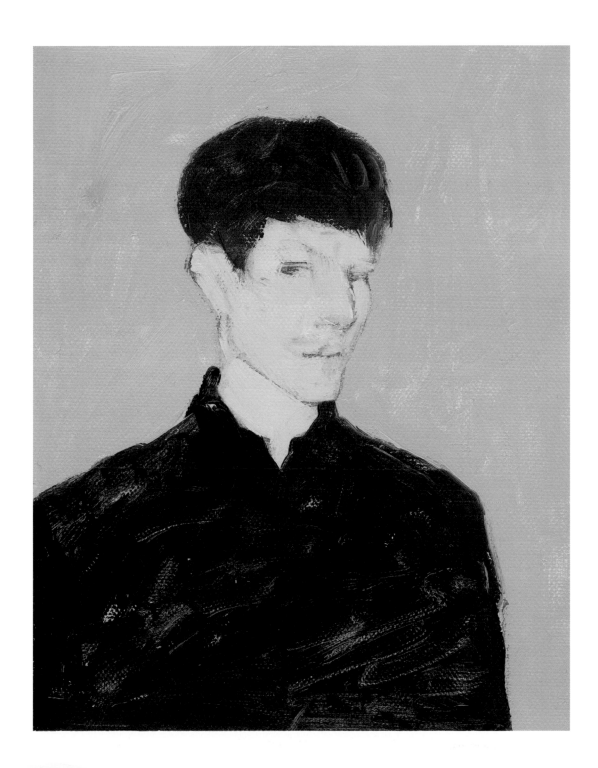

Stage 3

Now you can block in the main colour values, getting the mid tone of the colours if you can. If that's too hard, go for the darker tone, because with oil paint it's always easier to paint light over dark than the other way around. Try to replicate the warmth or coolness of the colours and how they contrast with each other. As you can see, in my example the background colour is about a shade darker than the skin tone and much lighter than the hair and clothing. The jacket is a warmer, slightly purple colour while the hair is almost pure Burnt Umber.

Stage 4

The next stage is to work into the main blocks of colour, defining features and colours. Showing the changes of tone on the face itself is clearly the most important thing, and then you can start to get a feel for the background intensity and the main shapes of the hair and jacket. Take your time over this and be careful at this stage to get everything in the right position, so that the face starts to become recognizable. Small things such the shape of the eyelids and the changes of tone and colour around the nose and mouth are worth spending time and effort on.

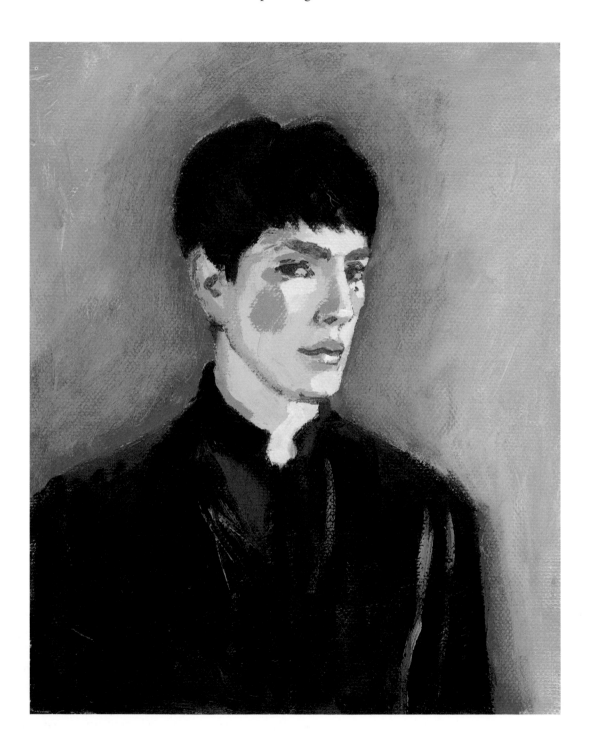

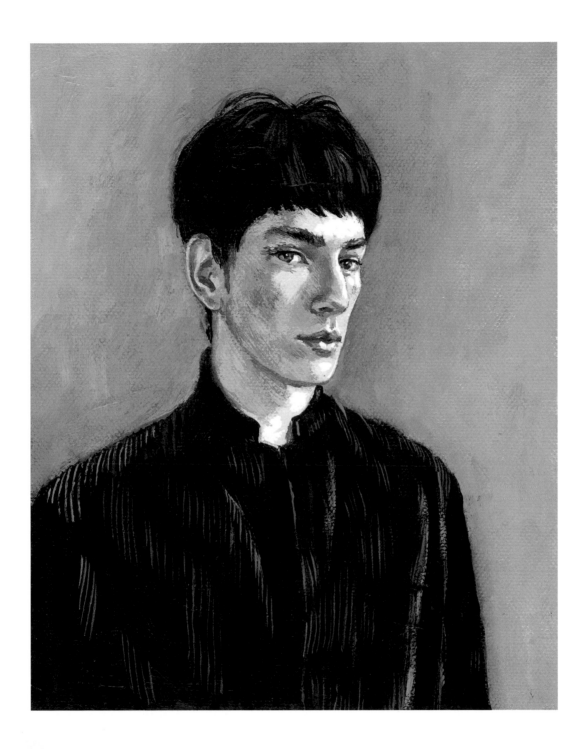

Stage 5

This stage is the slowest and most important part, because now you will be refining your portrait so that it will begin to look like your sitter and every mark you make, no matter how small, can change the look enormously. So keep at it until you're satisfied that you have got everything as correct as you can, and even ask for an opinion from someone else because they will be able to see things that you might have missed. Don't be discouraged if they come up with lots of suggestions for changes, because there are probably only one or two small things that aren't quite right. In the end, you are the one who decides that you've done all that you can, and when you reach that point, stop. If nothing is wrong then it must be right!

A YOUNG WOMAN

After the initial portrait of the young man, my next example is a young Russian woman who is the wife of a friend of mine. He wanted a portrait painted so I went about it in my usual way, meeting the sitter and agreeing when and where to paint her, then making several drawings of her to familiarize myself with her features. Then came the portrait proper.

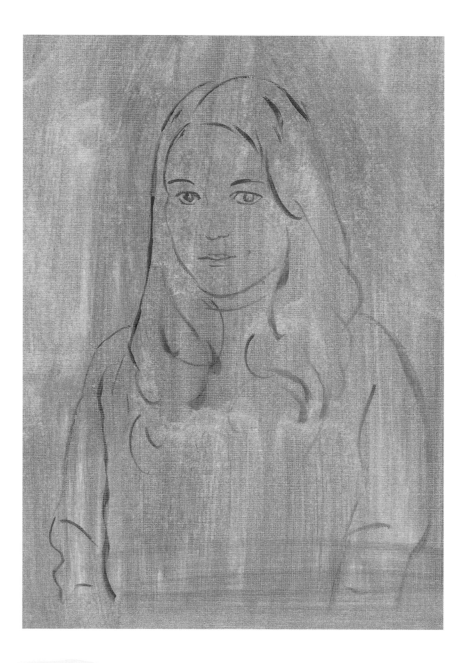

Stage 1

With music playing to relax the sitter, I began to draw in the main outline on a prepared canvas with a brush, then delineated her features and some indication of how her long hair fell.

124

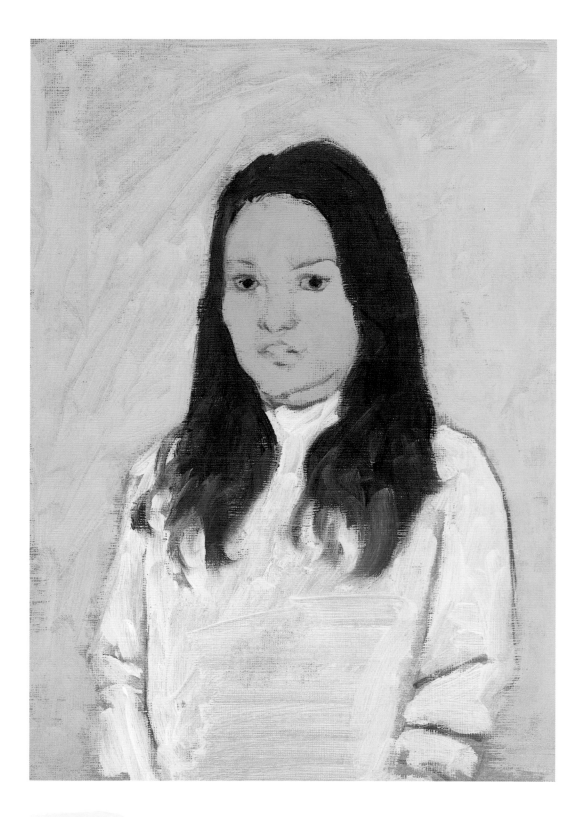

Stage 2

Then came the blocking in of the main colours, with the sweater being the lightest colour and the hair the darkest. The background and the facial tones were similar, but the face was much warmer in colour than the background.

125

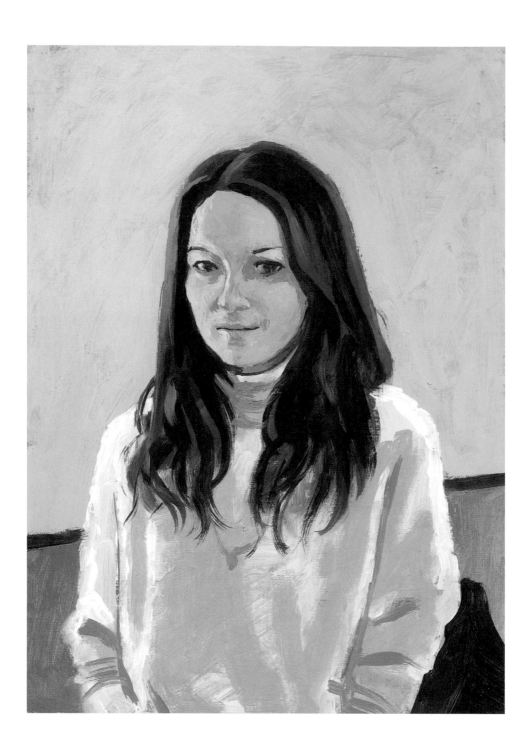

Stage 3

Next I defined her features, the folds in her clothing and the strands of her hair. At this stage the build-up of colour values is most important, then the careful exploration of the real shape of the eyes, nose and mouth.

126

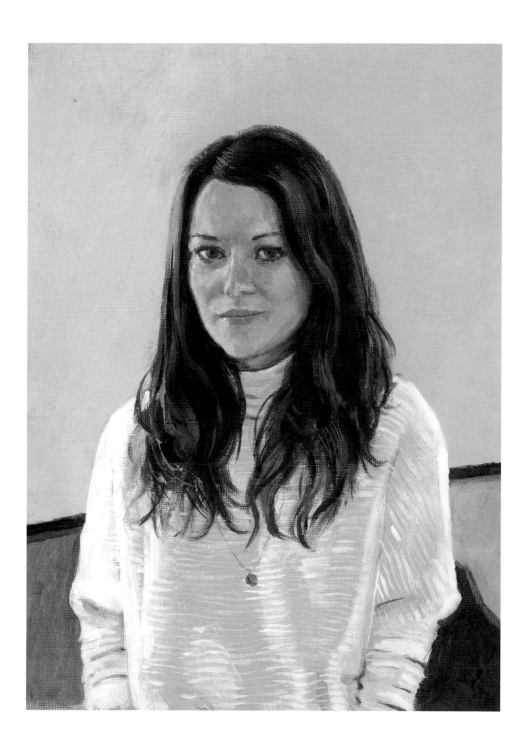

Stage 4

Having arrived at a reasonably defined portrait, I now had to refine each detail until I could no longer see anything that needed correction or extra subtlety. This is where the careful melding of colours to create the right changes of tone and colour is worth taking plenty of time over. I worked on the face first, because if that didn't look right my friend wouldn't have wanted the portrait. Then a lot of time was spent on the hair, which wasn't so difficult, because a hair or two out of place wasn't going to make much difference. Finally the clothing and the background were done relatively easily, although the whole picture does have to work overall in terms of shape, colour and tone.

OLDER MAN

The next example is of an older man, who is sitting at his desk in his study smiling at the artist. He's wearing spectacles, which are always a hazard in a portrait because they slightly distort the size of the eyes and also catch the light easily, which can add odd reflections. However, this sitter's position meant that the spectacles were not too dominant on his face and as it was half in darkness they added a nice crisp touch to the portrait.

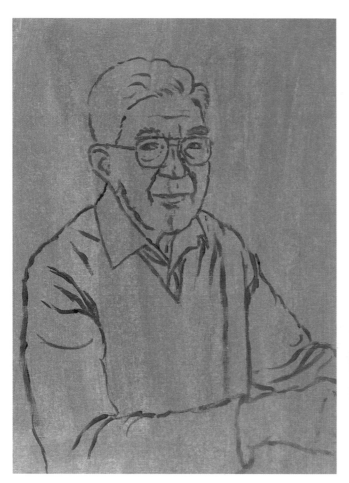

Stage 1

As usual, the first thing was to draw up the main shapes so that I knew where everything was going to be on the canvas. It's always useful to settle on a precise place for the sitter to direct their gaze, so that if you need several sittings they will be able to reproduce the pose exactly.

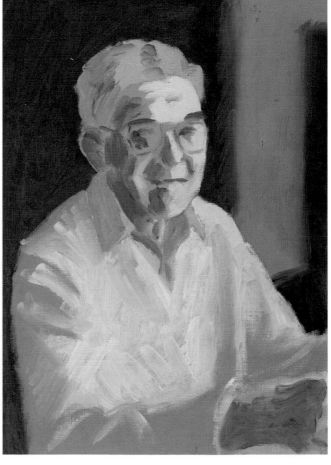

Stage 2

Blocking in the main colours was interesting because there was a strong contrast of blue and yellow in the clothing, and the hair was lighter than most of the tones on the face. Also, the background was quite dark and the light falling on the face was fairly bright.

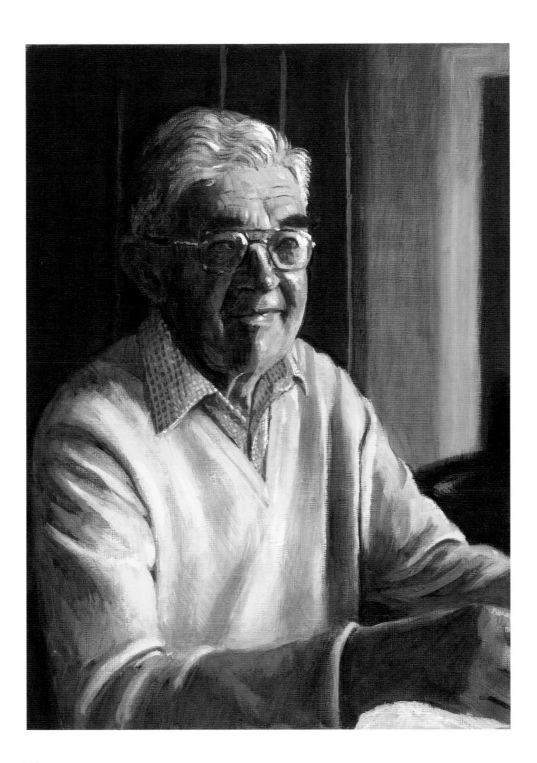

Stage 3

From then on the task was to get the necessary subtle tones and colour variations into the portrait to make the sitter look full of life. You can often paint enough detail and tone to give the right three-dimensional feel, but if you don't introduce enough liveliness in the detail the portrait won't be so interesting; the figure should look as though he or she could get up and walk away. So the careful observation of the marks around the eyes and mouth, the way the hair curls and the vigour of the colour in the face all help to bring the figure to life.

129

PROFILE OF A WOMAN

Here's a portrait of a woman past her first youth, her strong face seen in profile with a limited amount of light falling on her head. This portrait is of someone with a powerful personality, so she doesn't need a lot of clues to identify her. The low lighting produces a very dramatic portrait that wouldn't suit many sitters, but this woman can carry it. The only decoration in the picture is the plain white collar on her dress.

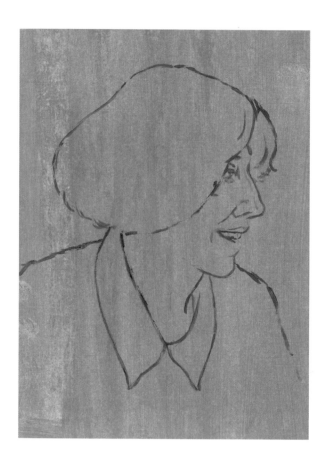

Stage 1

Once again the outline drawing in brush on a prepared surface was the first stage. Because there are no extra parts to the picture, it was essential that the features were as exact as I could make them.

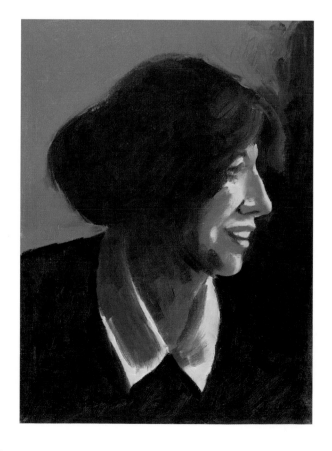

Stage 2

Next came the putting in of the local colour, which is not very varied, being mainly a dark to light greenish background with very dark clothing and dark hair. There wasn't going to be a lot of detail in this picture except for the features, so I had to make sure that they stood out in the right way. Most of the face is in darkness, except for the sharply lit eyes, nose, mouth and chin. The colour is subdued but rich.

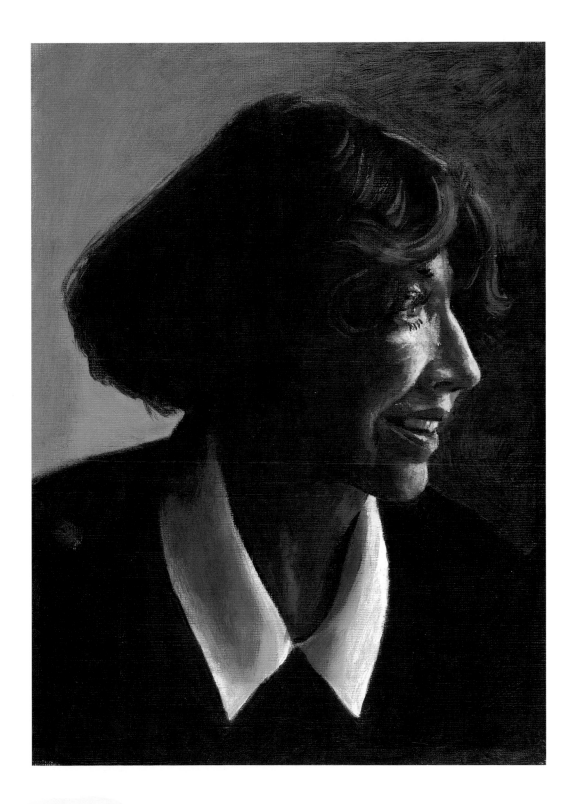

Stage 3

In the last stage, bringing out the texture of the hair and the details of the face was the only way of telling the viewer about this person, everything else being sombre. So I had to take plenty of time to get these details right in order to produce a strong, dramatic portrait.

131

DIFFERENT PORTRAIT TECHNIQUES

It isn't always necessary to have an all-over detailed piece of work to achieve a successful painting. Sometimes it's better to keep the painting broad-brushed or more graphic in its method to produce a good portrait.

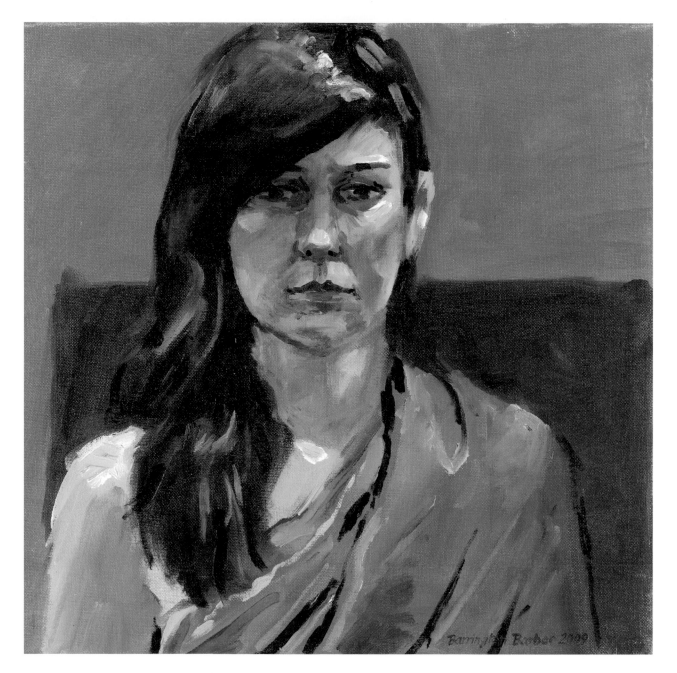

Sangeeta
Here a portrait of a young singer has been left with all the brushmarks showing so that the energy of the actual painting technique is evident.
I made no attempt to blend in any of the colours, but it still seems to work.

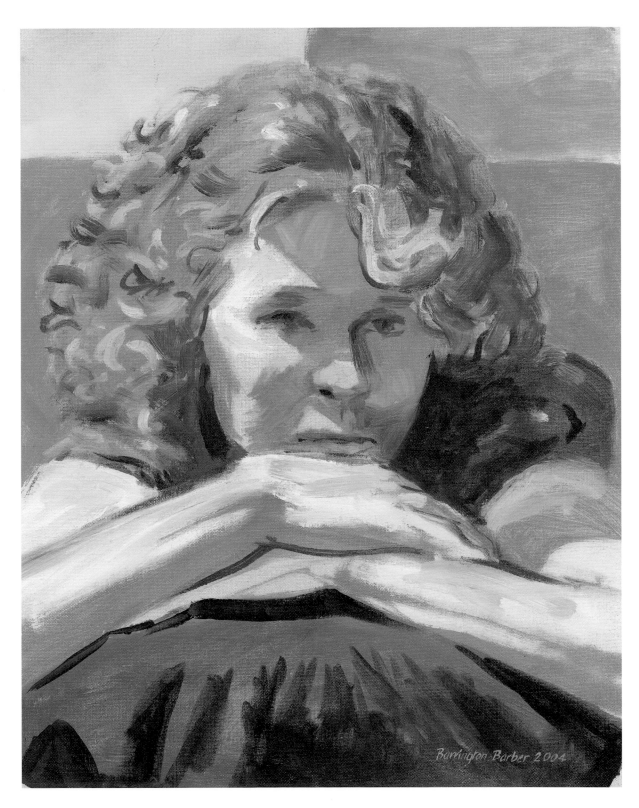

Pensive Woman

This portrait of a woman leaning pensively on her hands was done very quickly with quite thin wet paint, so that there was a blending of colours but a limited attempt to work in any detail. This was partly because there was not much time to do that, but also because it works as an effective technique in painting. The amount of time you spend on a painting isn't necessarily related to its success.

133

SELF-PORTRAIT

The benefit of drawing your own portrait is that you can take all the time you like. Use a large mirror that you can get relatively close to, because the distance you are from the mirror is doubled when you see the image. Good lighting is essential and if you want to paint a more profile view you will also need two angled mirrors, such as you find on a dressing table.

Take exact note of how you have positioned your head so that you can come back to the same pose each time you look up. The best way is to move your head as little as possible while you are painting, and if you can arrange your pose so that you only have to move your eyes, so much the better.

Stage 1

Starting with a canvas prepared with a Burnt Sienna ground, I began to draw my portrait. This stage is when you settle the angle of view and put in outlines of the whole head and all the features. Include any obvious background, but don't be too detailed about this – the main point is the head. As you can see in my drawing, I have put in the edge of my canvas and a suggestion of the ceiling and wall behind me. Keep correcting your work until you are satisfied that you have a good likeness.

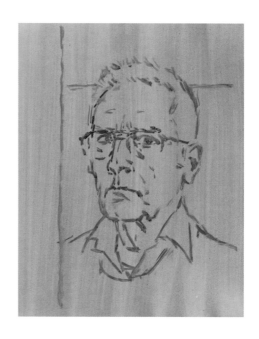

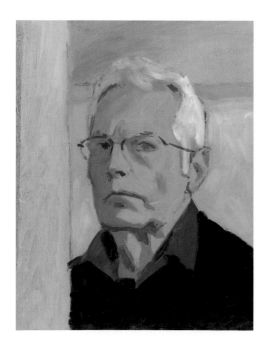

Stage 2

Now block in the main areas of colour and tone, keeping them as simple but accurate as you can. Here I put in a background of a greenish-grey, with the canvas edge in a warmer tone. I then blocked in the main flesh colour, which is a warm browny-pink colour from Burnt Sienna, Naples Yellow and Titanium White. I put in the shadows on the face very simply, using the same colours but with less white, and added some tone on the hair.

To take it to the next stage I further darkened the areas around the eyes, nostrils and mouth, and the shadows under the chin and near the hairline. At this stage your own painting should begin to look a bit like you, but still very simply done.

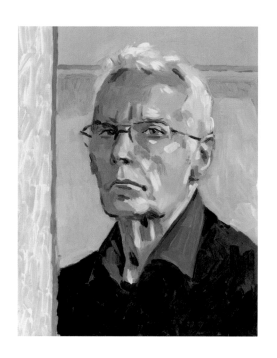

Stage 3

Next I worked on all the subtle colour variations on the surface of the skin until it began to resemble the colour and tonal value of the face in the mirror and the modelling of the features was clear. The highlights were put in next to get some idea of the contrast between the darker parts and the brightest lit. When you have finished this stage you should have a good likeness of your head but still rather impressionistic, although all the form should be obvious.

Stage 4

The last stage was where I really had to concentrate hard. Once the paint had dried, I slowly and carefully added variations of the colours until the rougher marks began to merge into each other and started to resemble real human flesh. Don't forget to put in the background work as you go along or else the tone and colour will become unbalanced. Everything must start to look much more realistic now, and this means emphasizing some parts and toning down other parts. As always, keep stepping back from the canvas to see the work at more of a distance, so that it's easier to check which colours to use. Sometimes you will only be putting tiny streaks of paint on the canvas in order to get the right quality of tone and colour. Don't give up until you can't see any more that needs to be done.

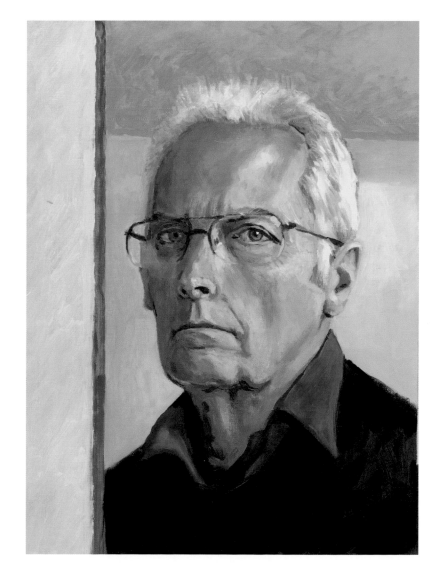

135

SELF-PORTRAIT TECHNIQUES

The self-portraits shown here are by British artists who have worked in slightly different ways. From them you will gain an insight into how, without losing a naturalistic approach, artists can vary the final look of a painting according to their different techniques.

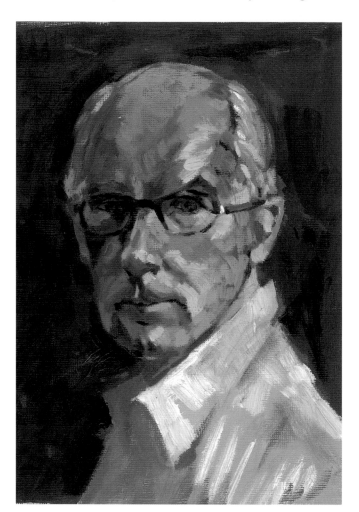

John Wynne-Morgan

This self-portrait by Wynne-Morgan is painted in large patches of pigment which he doesn't try to smooth out later, leaving the brushmarks evident. It's a very powerful way to paint, but you have to get the marks in the right place to make it work.

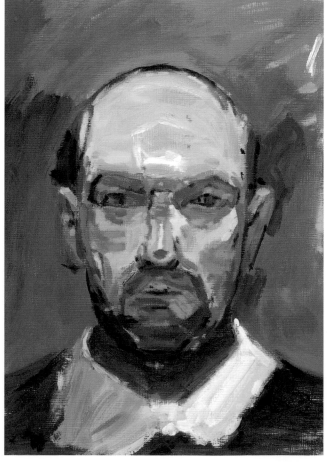

Euan Uglow

Uglow was renowned for measuring every mark that he made on the canvas. This usually meant that his paintings took a long time, but were very accurate. He hasn't hidden any of the measuring marks that help to define this painting.

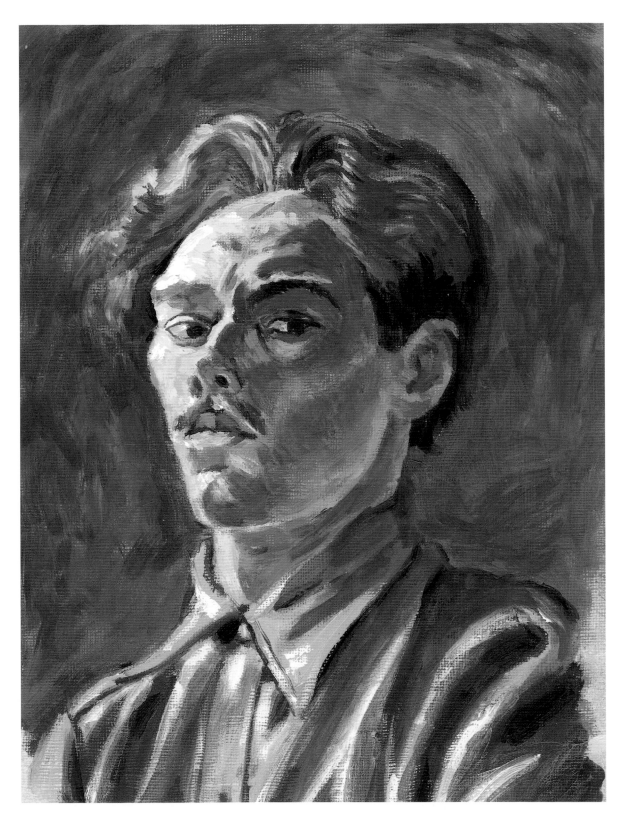

Jack Simcock
This artist works with large, swirling strokes of the brush and then patches in the more detailed areas with quite thick paint. This results in a dramatic self-portrait with a great deal of energy showing in the technique.

FIGURE PAINTING AND COMPOSITION

When you're painting a human figure the main thing is to convey the feeling of movement and, where there's more than one, to make a successful composition of the several figures in the picture. The human figure is in fact the hardest subject that you can paint, because it's familiar to everyone so it's easy to see when the drawing is not correct. It's such a complex piece of machinery that you will need to look very hard at the disposition of the limbs and torso to show a convincing person.

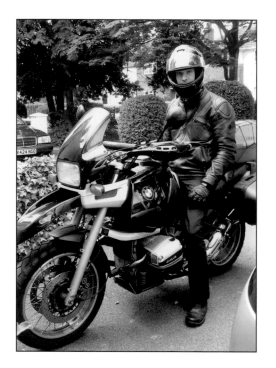

On My Bike

The best thing is to start with a single figure in a setting, and I have chosen a picture of my eldest son sitting on his motorbike to illustrate the point. The main thing is to get the combination of machine and human being together so that the whole picture makes sense from the angle that you are seeing it. First of all I photographed him and then used the photograph as the main sketch for the finished painting, because he wouldn't have wanted to pose for very long. I also made some drawings of the scene that would help with some of the details later.

Stage 1

First of all, on a prepared canvas board, I sketched in the main shape of the figure and bike with Burnt Sienna. Some outlines of the background details were also put in so that the scene was set for the painting as a whole.

138

Stage 2

Then I blocked in the main colours and shapes in a simplified way so that the whole composition was clearly shown in its colour values.

Stage 3

Next I began to work on the details of the figure and background, adding the darker and lighter tones to differentiate the qualities of the vegetation in the background and the leather-clad figure and the heavy machine in all its shiny hardness. This part of the painting was the most difficult, because I had to make sure that the machine and the figure didn't blend in too much despite both being very similar in colour. I kept the brush strokes fairly broad, so that I didn't get too refined in the detailing and lose the strong solidity of the shapes. In the final result the paint marks are still clearly seen, reducing the sharpness of the detail in preference for the strength of the statement that the paint makes.

TWO UP A TREE

In the second painting I have used a pair of figures, and this time they are my young grandchildren up in a pear tree in our garden. They were quite pleased with the idea of being in a picture but even so they were unlikely to stay still for very long, so photography was called for again to fix their pose. In this composition the younger child, the girl, was closer to my viewpoint, and the boy, although older and bigger in size, was further away and therefore looked smaller.

Unless you are attending a life class, where all the models are professional and can remain still for some time, you will mainly have to use photographic reference as I have done to get all the information that you need in the compositions.

Stage 1

On a prepared canvas, I drew in the main outlines of the branches and the two figures, which were partly hidden by the larger branches. Partially obscured figures frequently occur in figure compositions, adding to the dynamic of the scene.

Stage 2

Next I blocked in the colour, which here was mostly the dark greenish-brown of the branches and the mass of foliage all across the background. The two children were both wearing blueish clothes and these were blocked in as well as their warm skin tones.

Stage 3

After this came the task of differentiating the light and dark foliage and the slashes of sky showing through the leaves. The texture of the larger branches was important, too, because it indicated whether a branch was nearer to or further away from the viewpoint. I kept the brushmarks fairly broad, so that the simple shapes of the figures could be seen against the varying texture of the leaves.

141

Figures In A Park

This very casual arrangement of figures is taken from an old photograph. As it was in black and white, giving tonal information only, I could make the colour values whatever I thought would work for the scene. I simplified the background quite a bit, as I wanted all the attention of the viewer to be on the main group of figures. All the edges of the figures are a little vague or soft so that they are not too sharply delineated against the background; it's only the tone and colour that defines them clearly.

In The Art Gallery

Here I combined two photographs to make a composition where the two figures on the left are pushed slightly forward and the others on the right spread out against the remaining background. The figures stand out from the background because of their brighter or darker colours. You can see how the angles that people adopt when they don't realize that they are being observed make a natural combination of relaxed shapes that a posed picture would never have.

Three Figures

This painting of my son, his wife and their little boy in a sunny garden is a fairly straightforward composition of three figures making a triangle in the lower right-hand side of the picture. My colour range is quite strong in tonal values so that the feeling of the sunny day is obvious. The method of painting is quite simple and without much small detail. When you begin painting it's always advisable to keep your work less rather than more detailed, as it allows you to gain an understanding of the way a simple image can be more powerful than a more complex one.

Life Study Of A Seated Woman

This example of a life painting, done in a costume life class, shows a professional model seated in the studio with subdued lighting. The background colours are mostly dark, and the dark dress and hair of the model echo this colour range. As you can see, the way the background has been painted in large swashes of tone is rather different from the painted marks on the model and the mattress she is sitting on. Here the brushmarks are worked

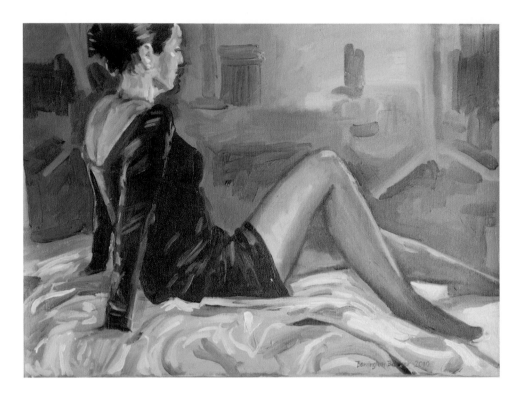

in two ways, sometimes blended to produce the smoothness of the stockinged legs and elsewhere left very obvious. The contrast between the lit areas and the darker tones also plays a large part in the lively surface of the picture. This was a very quick painting, produced in one sitting, and this also lends a certain panache to it.

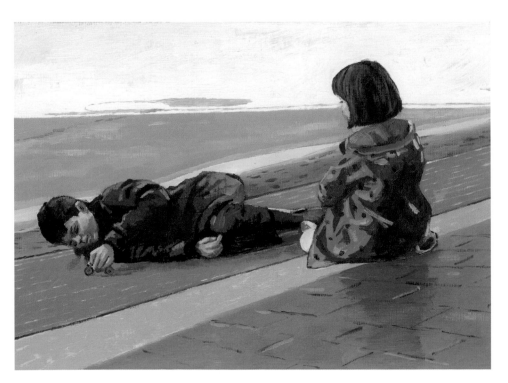

Children Playing

Here are two children playing on a pavement. The weather is damp and they have both got rainwear and wellington boots on. There's a pleasing contrast between the boy's dark clothing and the girl's shiny crimson macintosh, both set against the grey of the rainy pavement, which helps to define the image. The lines of the pavement slabs are cut across vertically and horizontally by the two figures.

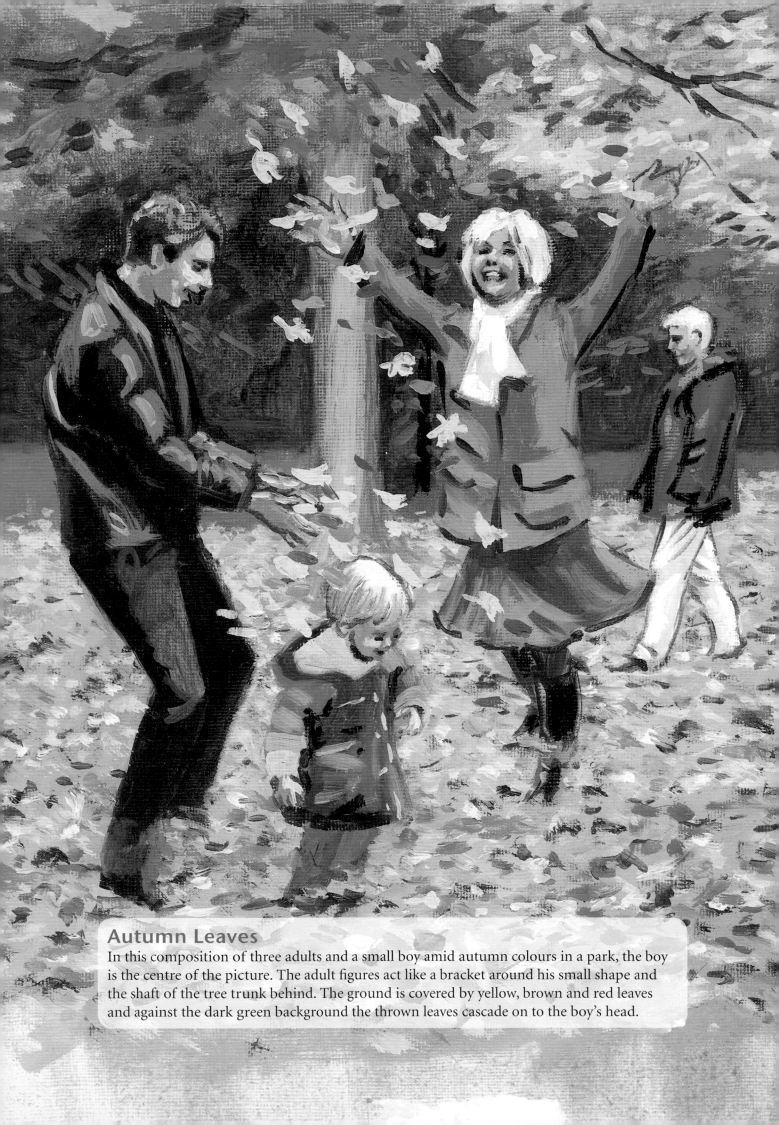

Autumn Leaves

In this composition of three adults and a small boy amid autumn colours in a park, the boy is the centre of the picture. The adult figures act like a bracket around his small shape and the shaft of the tree trunk behind. The ground is covered by yellow, brown and red leaves and against the dark green background the thrown leaves cascade on to the boy's head.

CHAPTER 6

STYLES AND COMPOSITION

In this last part of the book we look at the styles of different artists and how they have approached their compositions. You will see that the Impressionist way of handling paint occurs quite a lot; this is mainly because it offers novice artists the opportunity to paint with less or more detail according to what seems feasible, and even if there's not a great deal of detail the result will still be acceptable. I have avoided artists who are more inclined towards abstract work, because when you're a beginner it's much more tricky to get a good result in that area of painting – some experience of straightforward naturalistic painting is required before you can easily adapt to more avant-garde techniques.

However, one thing that all artists should do is investigate the work of other artists, and when you come across those whose style is to your liking, aspire to learn how they constructed their pictures and see if you can paint in a similar way. This is how most artists progress in their style and ability – and picture composition is one of the things that you will never stop learning about.

I have endeavoured to make approximate copies of the paintings, which are all by artists who are well worth studying. None of these examples is exactly like the originals, but making copies of works by master artists is a time-honoured method of improving skills. Unless you are an expert technician you won't be able to make exact copies of another artist's work, but you only need to make a good effort to understand why they painted the way they did. What you will discover is that they had good reasons for making their particular marks.

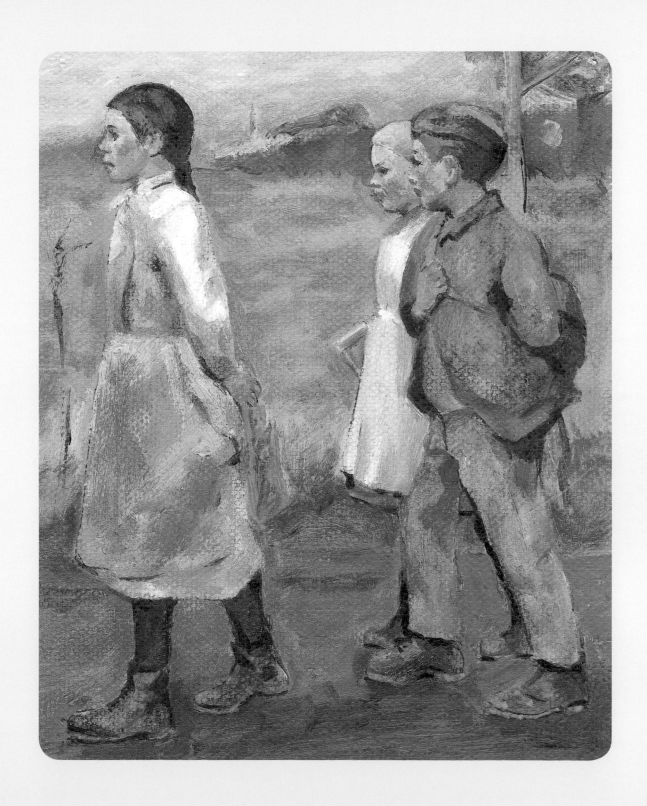

STILL LIFE

Here are three copies of still lifes by artists who use a rather impressionistic method of working where the marks on the canvas aren't tightly painted, allowing a general feel of substance without sharp edges defining the objects. In all these examples the marks are both loosely painted and precise, convincing you that you are looking at a real scene in time and space. The way in which light bounces off surfaces and sometimes seems to melt the precise edges of the objects is remarkably well painted.

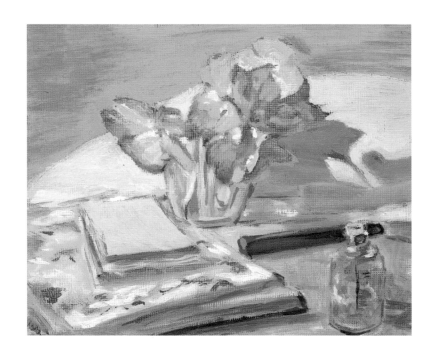

William Nicholson (1872–1949) was a famous English painter, justly admired for his beautifully painted work. This copy of *Begonias*, an arrangement of flowers in a jar with books or folders, sealing wax and a glass bottle, has a harmonious range of colour. Nicholson relies on the play of light across the scene to bring out the intensity of the colour and the glitter of highlights on the various objects.

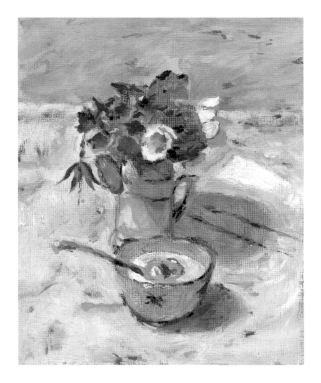

The next example, a copy of *Late Summer Flowers* by Diana Armfield (b.1920), also contains some flowers in a jug and in front of that a bowl with a spoon in it. The whole composition is bathed in sunlight and the edges of the objects melt slightly into the background area. She is an artist who is expert at getting the close tonal values of colours to work next to each other, which again produces an effective way of showing how we see things.

148

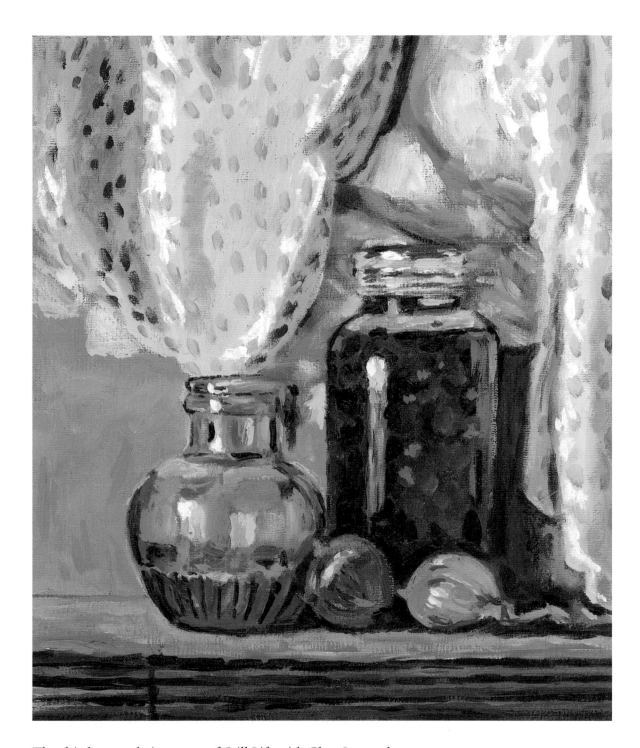

The third example is a copy of *Still Life with Glass Jars and Onions* by Vanessa Bell (1879–1961), who painted in the generation between Nicholson and Armfield. Here she has draped what look like curtains across the back of the picture, behind a shelf on which two glass jars and a couple of onions are placed. The scene looks like the corner of a kitchen. Again, she has allowed the painted marks to be loose and impressionistic, with the strong colours contrasting with each other and the light shining brightly off the surfaces.

LANDSCAPE

Now let's look at the great outdoors, which is an attractive subject for painting. The three examples here are two copies of great masters and one of my own paintings. I don't claim parity with these masters, but showing some of my own work against theirs will hopefully encourage you to see that you mustn't be daunted by them.

This example is from the great British master of the genre, Joseph Mallord William Turner (1775–1851). It is a copy of his *Norham Castle, Sunrise*, which has a marvellous quality of appearing to melt all the scene into a great abstract bath of light and colour, where everything is glimpsed but not seen sharply. The effect of light bouncing off the watery meadows and lake and the mist-enshrouded castle making a ghostly shape looming up in the background give a splendid evocation of space and open air. This was a painter who influenced the French Impressionist school of painters, and you can see how amazingly fresh and new this method of painting must have appeared at the time.

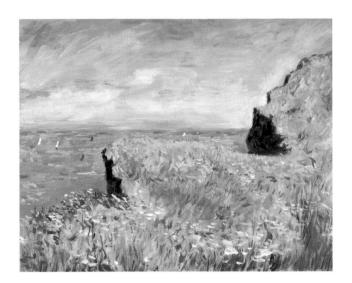

Now comes a copy of a painting by that great Impressionist artist Claude Monet (1840–1926). What we see in *Edge of the Cliff at Pourville* is an amazingly spacious sky over a glimpse of the sea, with verdant cliff-tops that the viewer seems to be standing on. The broken texture of the paint-marks of the vegetation contrasts nicely with the sweeping marks of the sea and sky. There is nothing too sharply defined, except for the dark rocky bits of the cliff-face that can just be seen. This feast of colour almost gives us a feeling of the warmth and airiness of the place – a brilliant piece of effective painting.

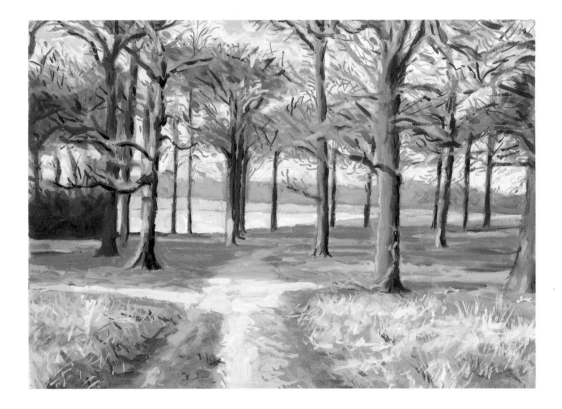

This painting is one of my own, derived from a photograph that I took in Richmond Park on the outskirts of London. The good thing about using a photograph for practising landscape is that it gives you all the tonal values you need to get the feel of the scene. I've drawn in the main shapes of the trees and landscape with solid strokes of paint, without showing any detail. The shadows on the tree trunks and branches are a mixture of very dark and lighter tonal marks, fairly loosely painted. The blocks of the sky colour showing through and behind the trees are put in to show up the pattern of the branches without being too precise as to each branch.

What is important here is the texture and density of the marks to give an effect of light and shade and to provide depth to the picture. There's no exact detail of any leaves or grass – just marks that give the effect of tree branches and vegetation. The colour values here are very carefully considered, but put on with speed and energy.

151

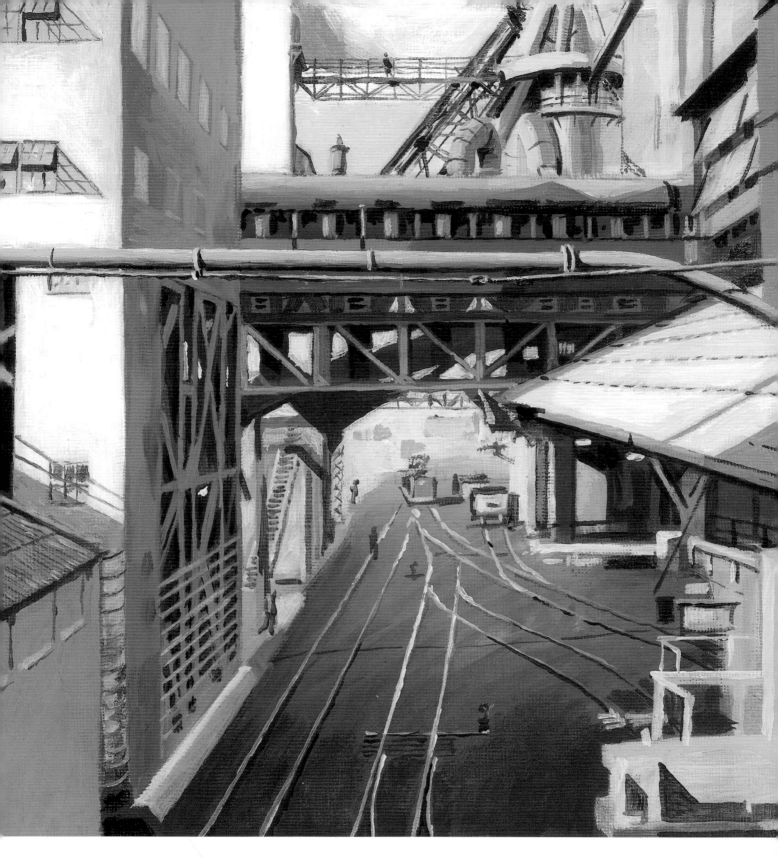

Urban Landscape

Here are two examples of what you might call extreme urban landscapes. The first is a copy of *City Interior* by Charles Sheeler (1883–1965), an American Realist painter. This is in no way as sharply delineated as the original, partly because I was painting it very much smaller and I haven't given it the intense accuracy that he worked to. Nevertheless, it gives you some idea of the almost photographic detail of his painting.

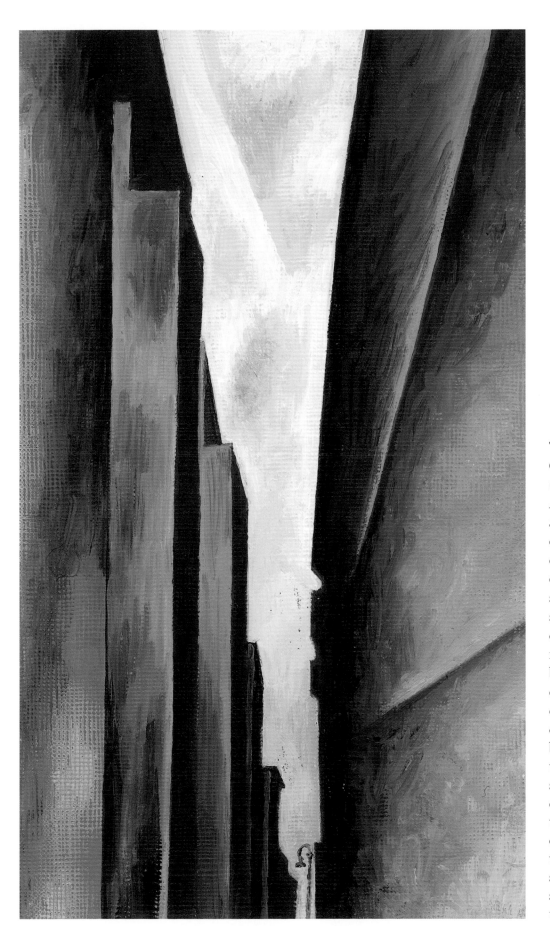

The second is by
Georgia O'Keeffe
(1887–1986), another
American painter.
Street, New York is
of a view along the
corridor-like shape
of a street with
skyscrapers on each
side; it's like looking
down through a
narrow slot at the sky
beyond. She leaves
out all detail, relying
on the monolithic
quality of the great
buildings to draw
the eye to the distant
street lamp. In their
different ways,
these artists have
departed from more
traditional street
scenes to paint the
starkness of modern
urban landscapes.

153

PORTRAITS

Looking at these paintings, it's clear that the same idea of not getting too caught up with the sharpness of edges can be an equally good way to paint portraits. These artists may use different techniques but they all have the same vigour about their work that makes it so attractive.

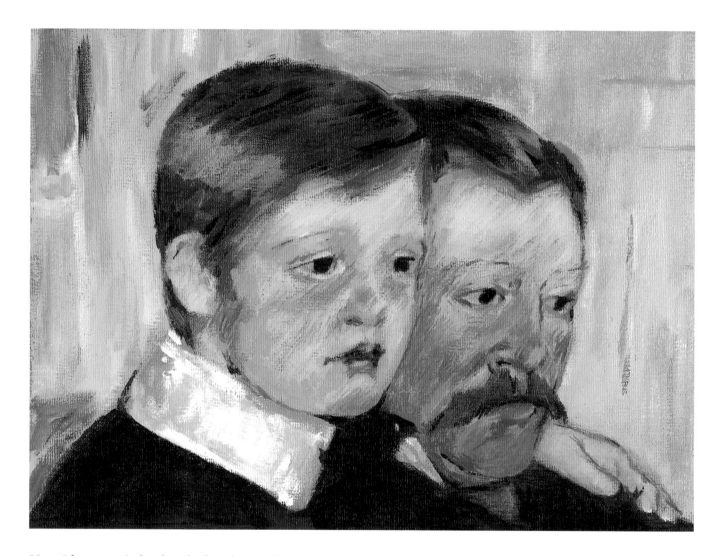

Here I have copied a detail of *Father and Son* by Mary Cassatt (1844–1926), an American painter working in Paris and a friend of Degas. Here she shows a father and son close together, with the colour of their faces contrasting against a pale background and dark clothing. Notice the diagonal strokes of the brushwork across the faces, which in no way reduces the substantiality of the volume of the shapes but makes the whole effect very believable and almost tender. She was influenced by the Japanese prints being sold and collected in Paris at the time, which showed how much you could reduce detail without losing the real substance of the picture.

The next piece of work is a copy of *Portrait of a Man* by Michael Andrews (1928–95), another painter from the generation of English artists who came to prominence after the Second World War. In this example he places the head of the character over to the side of the picture, rather like an off-centre photograph, caught by chance. His handling of the paint is quite loose, with a bravura effect of blocks of light and shade having been swept across the surface quite quickly. The drama of the pose is more important than the detail of the features, and we somehow get a good idea of the character of the sitter in this way. Expression is everything and all else is subordinate to it.

This is a copy of a painting by the great British master Lucian Freud (1922–2011), called *Woman with Eyes Closed*. His extraordinarily vigorous brushstrokes give an impression of speed and solidity, although he was quite a slow and deliberate worker who often had his subjects sitting for long periods of time. The masterly way in which he defines the substance of his sitter is remarkably effective, and gives the feeling that he didn't miss out anything at all – even the texture of the paint seems to tell us how the surface of the skin, hair or bone structure must have appeared. There is a certain exactness about the marks he put down with such energy.

155

FIGURES

These paintings copied from the work of Scottish, English and French artists give you some idea of the different ways in which you can approach the human figure in a setting. The background is important because it holds the figure in a scene, which makes it more convincing to the viewer.

In this copy of *A Hind's Daughter* by James Guthrie (1859–1930), a young girl is cutting cabbages for her family. Guthrie has used a very muted range of colours with warm autumnal tones, apart from the brighter patches of light on the knife and the white blouse. Again the detail is reduced to show the form more solidly and the atmosphere engendered by the warm, closely linked tones gives the painting a gentle strength.

In Guthrie's painting *Schoolmates*, three young children are arranged formally against a simple countryside background. This painting is even more muted in its tonal values, with even the white clothes hardly brighter than the darks. The overall effect is that the edges of the figures are not sharp against the background and all details softly melt into the larger shapes.

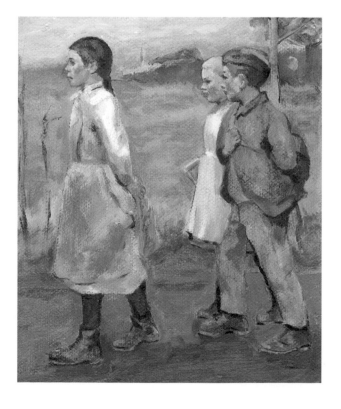

In this painting, a copy of *Peasant Girl at Grez* by Arthur Melville (1858–1904), the figure is much more sharply defined and is brightly lit by the sun. The branches of the vine show clearly against the white wall of the cottage and the pale colours of the girl's costume look almost faded in the light. The paint is handled in strong, definite marks on the canvas, which gives the form strength and graphic distinction and also an effect of immediacy. Melville has made the pattern of the shapes caught in the contrasting light very clear-cut, with the face of the girl almost hidden in the deep shadow of her scarf.

Next, a copy of a picture by Henri Matisse (1869–1954). In *Seated Odalisque*, he has painted a great variety of colours in the clothes and background. He hasn't tried to be exact in drawing the outlines of the shapes, allowing his expert handling of shape and colour to show itself in the simplest possible way. The colour is almost totally flat; Matisse seems to be more interested in the pattern that the colours make against each other than in any attempt to convey solidity or depth. So this is another way that you can use your paint on the canvas, making the colour and shape do all the work for you. You will need a confident understanding of how to do this to be truly successful, but you should attempt it sometimes in order to see how effective it can be.

This next painting is one of my own, showing a professional life model. Because it was painted in one short sitting there was no time to become involved in any detail and I have used quite broad brushstrokes with no attempt to meld the tones and colours into one another, so it's fairly easy to see how the paint was put on. This is a good method for a beginner, because it's simpler and you don't get caught up with the careful grading of tones and colours. Keep the palette limited, as I have here, in this case to Naples Yellow, Burnt Sienna, French Ultramarine, Burnt Umber and Titanium White.

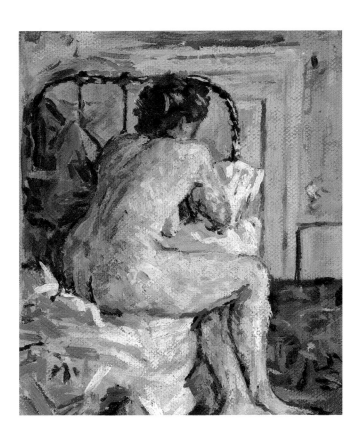

Nude on a Bed by Harold Gilman (1876–1919) was influenced by Sickert's studies of the nude, and Gilman uses a very strong impressionist technique here. Some of the stipple effect of the brushstrokes resembles Pointillism, which was a rather more extreme version of Impressionism. But not all of the painting is like this – as you can see, there are strong brushstrokes, especially on the bed-sheets, which use much broader marks. The colours are fairly muted, except for some marks in bright red, which give a little more fire to the composition.

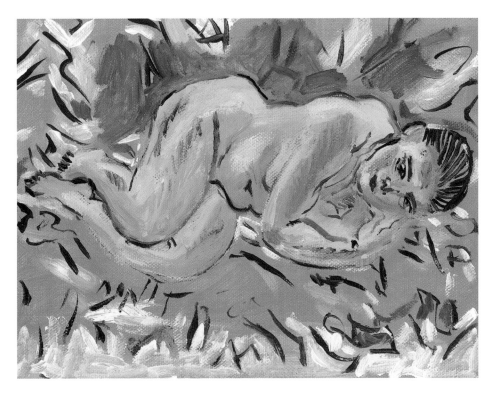

This copy of *Female Nude* by Raoul Dufy (1877–1953) is almost a drawing in paint. He hasn't tried to make a lot of modelling on the figure, preferring just to give a general tonal change to suggest volume and relying on the fluid graphic lines to indicate the shape and substance of the body. His background is also minimally described in a fairly linear way. He was a master of this style of painting, and while it isn't as easy to make it work as one might think it has the advantage of economy of colour and modelling that is helpful for a novice painter.

159